ıistory
ercolours

DATE D

A Concise History of
Watercolours

A Concise History of
Watercolours
Graham Reynolds

NEW YORK AND TORONTO

OXFORD UNIVERSITY PRESS

© 1971 THAMES AND HUDSON LTD, LONDON

Reprinted 1978

All Rights Reserved

Library of Congress Cataloging in Publication Data
Reynolds, Graham.
 A concise history of watercolours.
 (World of art)
 Includes bibliographical references and index.
 1. Water-color painting—History. I. Title.
II. Series.
ND1760.R4 1978 759 77–26338
ISBN 0–19–520051–9

Printed in Great Britain by Jarrold and Sons Ltd, Norwich

Contents

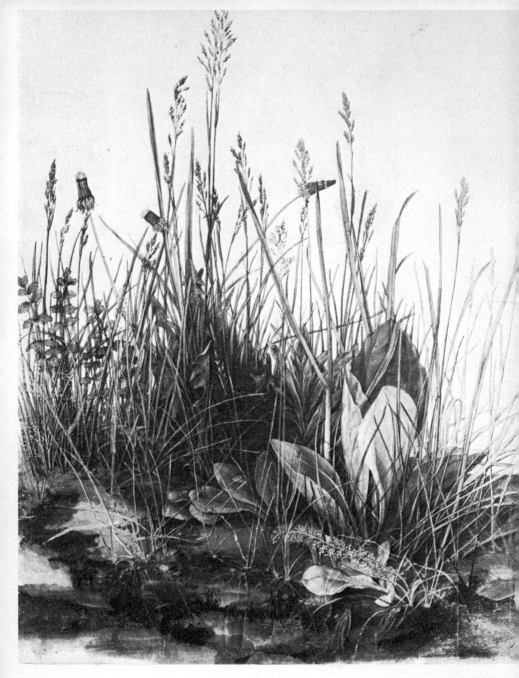

1 ALBRECHT DÜRER, *The Great Piece of Turf*, 1503

The beginnings of watercolour painting in Europe

The first question to be settled about watercolour painting is why, and within what limits, it forms a subject of special appeal for the collector, the historian or any other person with an interest in art. In most sectors we do not usually differentiate works by reference alone to the material in which they are carried out. The study of Italian Renaissance sculpture is applied with equal diligence to works in marble, plaster or terracotta; a history of fifteenth-century painting dwells with the same emphasis on temperas and oils. What then is so unusual about watercolour that artists have been known to confine themselves to its use alone; that it is the subject of specialized study, and that collections continue to be formed solely of paintings in this medium?

The answer to this question is partly that, because this method of painting has expressive powers peculiar to it, its products are of a different nature from contemporary work in oil and tempera, or monochrome drawings. However, an examination of the great collections soon convinces us that the period when these differences were most significant was the eighteenth and nineteenth centuries; further, that it was within the British school of painting that watercolour was, for the longest time and in the most distinctive way, a mode of expression in its own right. Accordingly this account of watercolour painting, or watercolour drawing, as it is called with equal frequency, must, as any such account, be devoted in large proportion to the British artists of the eighteenth and nineteenth century. Not by any means exclusively however; the origins lay elsewhere; there are forerunners, mentors and parallels in Europe and it is only a myopic view which attempts to encompass the British contribution, far-reaching as it is, without reference to

7

earlier and contemporary developments in Europe and, later, in America.

It is also necessary at the outset to attempt to draw a line of demarcation between watercolour drawing as it is generally understood and certain cognate forms of painting which have a close affinity to it. These are definitions more of custom than of absolute logic, and recent practice has started to erode them; but, up till about 1900, a wide measure of agreement had been reached on what constitutes a 'watercolour drawing'.

To begin with the pigment: this is colour ground or suspended in a water-soluble medium such as gum. The instrument with which the drawing is executed is the brush, and the usual surface is paper. Since the layers of pigment placed on the surface are very thin, light is reflected from the white background through the colour washes to produce the brightness of tone, freshness of colour and luminosity of effect which are the watercolour's characteristic assets. If a painter, otherwise working within the watercolour's limitations, desires less transparency and a thicker texture of paint, he can mix his pigment with opaque white, forming gouache or, so-called because it has more 'body', bodycolour.

A good many examples of art in other media show analogies with some aspects of watercolour. There are paintings which come close to the visual appeal of watercolour because they depend for their effect on pure, thin pigment lit up by a light ground. This strand in painting can be traced backwards in time through fresco and classical wall-painting to the decorations of the cave men. On the other hand there are drawings on paper, carried out in whole or in part with the brush, which share their qualities of draughtsmanship with watercolours, without the variety of colour in the true form.

Of all forerunners, the illuminated manuscript comes closest to being the direct parent of watercolour painting. The decorated pages of a missal are executed in bodycolour, and watercolour, on vellum; yet by common consent they are not regarded as 'watercolour drawings' in the same sense as those

8

discussed in this book. There are a number of good reasons for this. The object of the illumination – to decorate a book, to express a private devotional mood – is different from the more public intention of the watercolour. The use of vellum instead of paper as a support imposes some restriction on the artist's freedom of approach. The extensive use of areas of burnished gold in book illuminations lends itself to a decorative element which is absent from the watercolour. It is only necessary to put illuminated manuscripts and watercolours side by side to see that they belong to two different species of painting.

The portrait miniature, which can equally claim to be descended from the illuminated manuscript, is also, by general agreement, regarded as having a history of its own, independent of watercolour. It is executed, in the sixteenth and seventeenth centuries, in watercolour and bodycolour on vellum; in the eighteenth and nineteenth centuries, in watercolour mainly on ivory. Here, the intimacy of approach and the concentration on iconography prescribes a distinguishable variation in attack and a different classification from watercolour drawing.

The second family of development, next to the illuminated manuscript, which enters into the development of the modern watercolour is that of the classical discipline of *disegno* or drawing. The medieval and Renaissance apprentice to a painter had to learn to draw. That is to say he had to trace the visible objects of his world, giving an outline and indication of its shading; this was generally done as a preparation for a painting or other work. The materials at his disposal were anything which could make a mark on paper or a similar surface; silver-point, charcoal, chalk, pencil, pen or brush dipped in ink or bistre. The extent to which the traditions of this training were carried over is shown by the circumstance that the term 'water-colour drawing' is virtually synonymous with 'watercolour painting'. But naturally the vast proportion of watercolours which have retained their interest into the present day were produced not as preparations for work in another medium, but as completed works of art in their own right.

It is the direct link with old master drawing that makes the question, 'when did watercolour painting begin?' a difficult one to resolve. At the same time this link is the most important source of the connoisseur's interest in watercolours. These drawings preserve, by the method of their composition, that sense of direct contact with the mind and the hand of the artist, the same power of communication through the details of handling, which is the primary appeal of old master drawings. For example, it is of little moment that Claude rarely used a tinted wash in his landscape sketches. He expressed atmosphere and sensibility through graduated tones of bistre, and his followers in England in the eighteenth century were content to aim at results of equal power, either with a modified series of monochrome tints, as did J. R. Cozens and Thomas Girtin, or with the full accessible range of watercolour pigment, as with Pars or Towne. We come to distinguish, both in the wider field of drawing and in watercolours alone, between two main types. In one the outline is of prime importance, and the washes, monochrome or tinted, applied by the brush, are ancillary indications of local colour. In the other, it is the graded washes which are of account, and the brush is the leading and may be the only instrument used in the construction of the drawing. As the British School reached its climax the more attractive aspects of the first group were combined with the greater free-dom of the second, so that transparent areas of coloured wash make their effect without being circumscribed by a taut outline.

The increased use of watercolour, in its modern connotation, came at the same period as the re-animation of man's interest in the visible world. Accordingly, one of its uses was for the quasi-scientific, quasi-artistic exploration of fact, for instance in botany and zoology. In its aptness for botanical illustration, indeed, it surpassed oil painting. Another general use for water-colour was in the applied arts. This became specially important when a design had to be sent outside the artist's own workshop for translation into some medium in which the colour was vital. A master painter could make drawings for his own

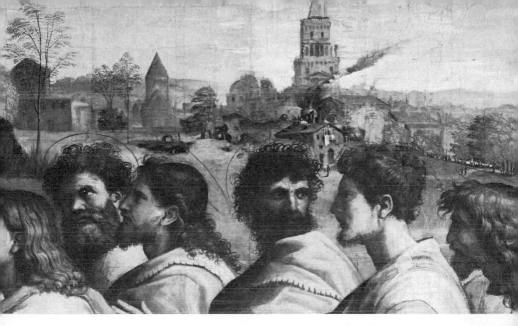

2 RAPHAEL, detail from the tapestry cartoon *Feed my Sheep*, 1515–16

paintings in monochrome, knowing what colour he had in mind for the final realization. But if he were sending designs for tapestries to be woven in a distant centre he had to indicate colour as well as form. It was for this express purpose that the Cartoons by Raphael came into being. When he was making the full-scale design now in the Ambrosiana, Milan, for the fresco *The School of Athens*, he only used black chalk and charcoal, heightened with white. But when directing the weaving of tapestries, also for the Vatican, he had to control the work of the Flemish weavers in Brussels. Accordingly the full-scale cartoons for them are in colour. The colour is fixed in a form of animal glue and mixed with white, so these vast drawings are in a kind of gouache, and are among the earliest and largest watercolours in existence.

Apart from their learned and natural manipulation of the figures in the scriptural drama, the Cartoons are notable for their naturalistic rendering of the Italian landscape. And landscape

2

was, together with natural history and the applied arts, a subject which benefited by being treated in watercolour, to such an extent that it became the predominant theme for the medium over four centuries.

Almost in the decade when Raphael was producing the Cartoons, Albrecht Dürer was developing the capacities of the water- and bodycolour medium toward their natural limits in these directions. So classical were his treatments of certain themes in natural history that they have become universally known; for instance, *The Great Piece of Turf* and *The Hare*. Dürer stands near the beginning of many different paths which the use of watercolour was going to take. In studies such as those of the hare and of crabs he embodied his perceptive and loving understanding of animals. His watercolours of flowers and weeds are remarkable for their observation and fidelity at the outset of modern botanical observation. Above all, his landscape drawings are complete statements in themselves, and anticipate the element which has always given watercolour its peculiar power. He sensed, at the very beginning of the use of water- and bodycolour as a means of painting independent landscapes on paper, that it had a greater capacity than oil to render nuances of atmosphere, and the changes effected in local colour by the intervening air. This property was rediscovered again and again, and was exploited to the full in the period of watercolour's most rapid advance. As records of his visits to Italy his landscape drawings have a further significance as early instances of the use of the medium for the quick notation of strange, exotic and beautiful scenes.

The main use of watercolour by the German masters who followed Dürer was for heightening the features in portrait drawings; a use to which Hans Holbein and Lucas Cranach resorted. The interest which the medium long retained for the amateur is reflected in the proliferation in Germany of the Stammbücher or Album Amicorum, the equivalent of the still-surviving 'album' in which sketches and inscriptions are entered by the owner's friends.

12

3 FEDERICO BAROCCI, *Landscape*, study for background of the etching
Stigmatization of St Francis

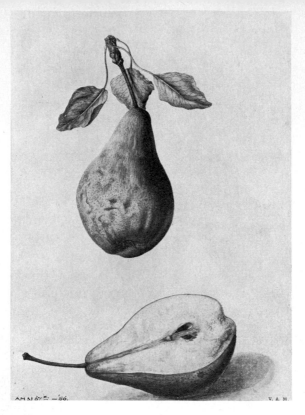

4
JACQUES LE MOYNE
DE MORGUES,
A Pear

5 JOHN WHITE,
*Indians Dancing
round a Circle of
Posts*

AM 31 67 ² — '56. V. A. M.

For a long time watercolour appears only sporadically in Italian drawing. Jacopo Bellini in his fine coloured drawing of an iris anticipated a study by Dürer of the same subject by over fifty years, but there is no connected tradition, only a succession of particular instances called forth by the exigencies of some 3 specific purpose. Federico Barocci of Urbino, for instance, whose favourite drawing technique lay in the use of coloured chalks, made a landscape in bodycolour which shows that he has as keen an eye for the nuances of atmosphere as the Northern artists. G. B. Castiglione of Genoa used watercolours at the outset of his career, probably as an offshoot of the training given him by Northern teachers. Then he developed a technique, peculiar to himself, of dry oil colour on paper which has affinities with the purer medium and anticipates some forms of

14

drawing on paper used again in the twentieth century. The subject-matter he treated in these drawings of his maturity was generally drawn from mythological or classical themes.

Natural history drawing shows a more connected development, no doubt because there was a strong demand for botanical illustration and other aids to scientific inquiry. Giacomo Ligozzi, acting as naturalist to the Grand Dukes of Tuscany, made a comprehensive series of studies of flowers in the latter half of the sixteenth century. In that period Jacques Le Moyne de Morgues, persecuted in France for his Huguenot sympathies, *4* came to England and made the studies of wild flowers and

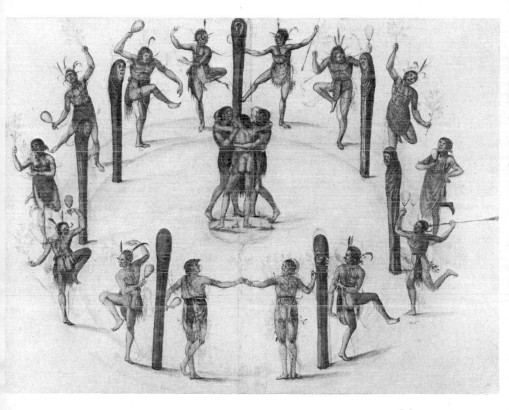

fruits which form one of the earliest national flora, and stand near the beginning of the English watercolour tradition. There are links between him, Theodore De Bry and John White, sometime Governor of Raleigh's second colony in Virginia. The tendency of the times to use watercolour for a pictorial inventory of strange places, strange peoples, new animals and new plants could not be better illustrated than by the series White evolved out of his experiences in Virginia, Florida and Baffin Island.

The facility with which a great painter could, if he chose, adapt his style to that of the coloured drawing is shown by the success of Rubens' landscapes. He preferred to make sketches for

6 PETER PAUL RUBENS, *A Stream with overhanging trees*, 1635–40(?)

16

7 ANTHONY VAN DYCK, *Landscape Study: a Path among Meadows*

paintings in thin oil on paper; but when he used bodycolour
for its own sake, as in the *Stream with overhanging trees* in the 6
British Museum, he almost casually demonstrated his complete
command of this method. Van Dyck turned to watercolour for 7
landscape mainly during the period of his employment by
Charles I. So from the outset the English landscape was rendered
with a *plein-airist* technique and a full sense of the prevalence
in it of natural colours modified by the atmosphere.

Jacob Jordaens did not, like these masters, regard watercolour
as a rare escape from oil painting and monochrome sketching.
He began his career as a *Waterschilder*, or painter in water-
colours, as an adjunct to his early employment as a designer of
tapestries. Long after he ceased to be exclusively concerned
with this applied art, he made considerable use of water- and
bodycolour in small drawings. In this way he used it quite
naturally for a complex figure composition such as *St Ives,*

8 *Patron of Lawyers*, which is said to antedate his oil painting of the subject.

It would be misleading to remove the watercolours produced in Holland during the seventeenth century entirely from the wider context of Dutch drawing. Though a large group of coloured drawings can be assembled, this forms only a small proportion of the vast production of the golden epoch in Dutch art. Yet in Holland in the seventeenth century we meet for the first time with a concerted attempt to produce watercolours for sale as finished works of art in their own right, rather than as steps in the production of another artefact. Many of the Dutch artists whose names are best known took part in this production,
9, 10 among them Hendrik van Avercamp, Adriaen van Ostade, Isaak van Ostade, Cornelis Dusart, Herman Saftleven and
11 Allart van Everdingen.

Their choice of subjects reflects the taste of a keenly independent, mercantile, largely Protestant people. Instead of religious themes and subjects drawn from history or classical literature, they preferred to turn their eyes on the world around them. In these circumstances landscape was a growing taste, and the rendering of peasant life equally important.

The greatest Dutch draughtsman of the seventeenth century, Rembrandt, did not use watercolour, though his use of graduated washes – like that of Elsheimer – is subtly suggestive of
10 colour. Adriaen van Ostade, however, made considerable use of colour in his sympathetic but realistic drawings of country life. He delighted in indoor scenes, such as a family circle in a farmhouse kitchen, or outdoor views with children playing round a cottage door. He kept his observation sharp by making studies of individual figures, and the acuteness of his perception, which extends to the kitchen crockery and the battered tubs outside the door, is matched by the liveliness of his outline. The ability to present in this way a convincing picture of the life of ordinary people, without embellishing it or glossing over its coarser details, reached its height in the Dutch art of this century. Other exponents of the genre who also worked in watercolour

18

8 JACOB JORDAENS, *St Ives, Patron of Lawyers*

are Adriaen's brother, Isaak van Ostade, Cornelis P. Bega and
Cornelis Dusart.

In the drawings of Hendrik van Avercamp the interest is 9
equally divided between the groups of figures absorbed in their
summer or winter occupations and the landscape in which they
live. Since the artist's disability – he was dumb – withdrew him
somewhat from contact with the village world of Campen, his
home, he was all the closer an observer of its ways. As with

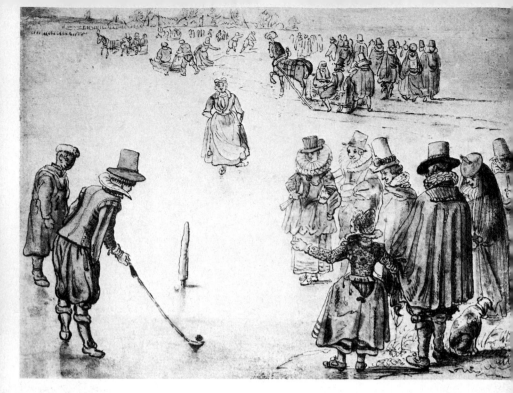

9 HENDRIK VAN AVERCAMP, *Golf on the Ice*

Adriaen van Ostade, his is a form of drawing which puts the emphasis on outline, and the washes are sometimes mono-chrome, sometimes in delicate tones of transparent colour. A favourite subject with him is drawn from the annual frosts of Holland, when the land is covered in white and the peasants skate, sleigh and play bowls on the frozen canals.

The Dutch were great travellers, and it was natural that they should play a large part in the development of pure landscape, both in paintings and drawings. While both seascapes, and views drawn from their visits to Italy were prominent, their first interest was the accurate topographical rendering of their own land. Philips de Koninck, a pupil of Rembrandt, devised his own methods for expressing the long, low panoramas of

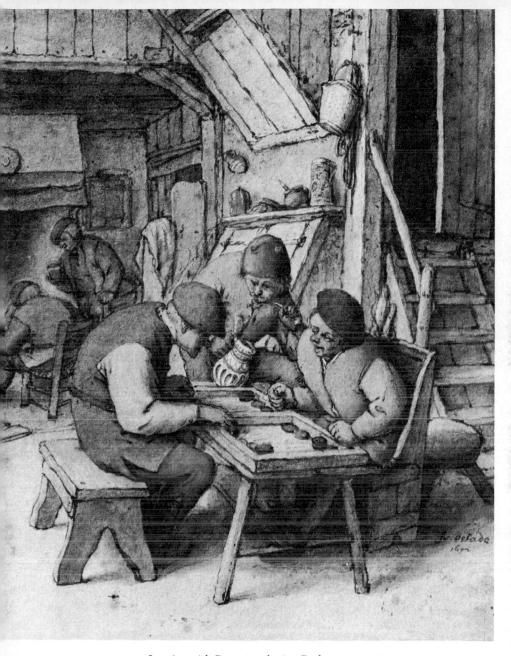

10 ADRIAEN VAN OSTADE, *Interior with Peasants playing Backgammon*, 1672

11 ALLART VAN EVERDINGEN, *A Hilly Road*

Holland and its distant horizons with a use of tinted washes derived from his master's practice in monochrome. Toward the end of the century Valentinus Klotz made distant panoramic views of towns silhouetted against the horizon, with outlines strongly suggestive of the use of the camera obscura. A similar method had already been practised in black-and-white by Willem Schellinks, whose travels extended to England.

11 Allart van Everdingen's journeys took a more unusual direction, towards Sweden. The Romantically tinged water-colour drawings which he made there soon after 1640, showing the most rugged of northern mountain scenes, have a wildness beyond that seen in the work of his contemporaries who

22

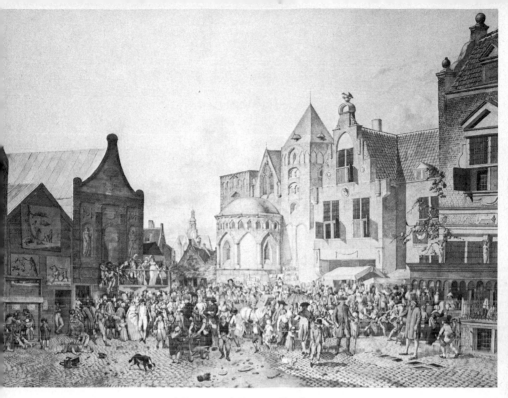

12 JOHANNES HUIBERT PRINS, *A Provincial Fair in Flanders*, 1805

journeyed through the Alps. How accessible they remained to the nineteenth-century taste for the sublime is shown by Constable's comment about the scenery in part of Leicestershire: 'the mountain streams and rocks (such Everdingens) at Griesdieu . . . a grand but melancholy spot'.

The great impetus which had inspired Dutch art during this epoch died down at the end of the seventeenth century. In place of the examination of the world at large, topographical interest became confined more narrowly to the townscapes of Holland itself. The production of works of this kind was encouraged by the pleasure collectors took in forming accumulations of views, called 'atlases', of towns, especially of Amsterdam. It was to meet

23

this demand that such careful draughtsmen of architecture as
12 Jacob Cats and Johannes H. Prins produced their meticulous
views of streets, with the inhabitants going about their business
in them. These have an affinity with similar town views pro-
36, 38 duced by Paul Sandby, Thomas Malton and other British
artists of the same period, the latter part of the eighteenth cen-
tury; but they seem to be the independent product of a natural

13
AERT SCHOUMAN
A Bunch of
Poppies

14 ALBRECHT DÜRER, *A Lake bordered by Pine Trees*, 1495–97

process of development within Dutch art rather than being in-
fluenced by, or the models for, the English equivalent.

But even in this less dynamic atmosphere there was plenty of
variety in eighteenth-century Holland. Cornelis Troost is 16
called, not without reason, the 'Dutch Hogarth'. A student of
the theatre and contemporary life, he is best known for the
series of pastels known as NELRI from the initials of their Latin
titles, showing the progress of a bibulous evening among a
group of friends. It was such gentle comedies of daily life that he
treated also in watercolour.

Among the botanical draughtsmen, Jan van Huysum 15
occupies an especially important place for his skill in composing
arrangements of flowers and fruit for his more elaborate
watercolours no less than for his studies of single flowers. He

25

15 JAN VAN HUYSUM, *Fruit and Vine Leaves on a Large Delft Dish*

13 has an ability in the use of washes directly applied which differentiates his work sharply from those who depend on an outline filled in with colour. Aert Schouman, who settled in The Hague about 1748, the year before Jan van Huysum died, is outstanding for the mastery and fluency of his watercolours of animals and birds, for which he found many exotic models in the Prince of Orange's collection. The survival of the Grand Manner in the decoration of houses in Amsterdam in the eighteenth century is seen in colour designs by Jacob de Wit and Isaac de Moucheron, while a more vigorous world of action is reflected in the late eighteenth-century battle scenes of Jan Anthony Langendyk.

26

16 CORNELIS TROOST, *Scene at the Entrance of a House*

18 BERNARDO
BUONTALENTI, *Designs
for costumes of two
female performers in the
Florentine 'Intermezzi'
of 1589*

As has already appeared, up till the seventeenth century the
Italians were not in the habit of embellishing their working
drawings with colour unless there was a special reason for doing
so, such as the designing of tapestries, or indication of require-
ments for theatrical costume – for instance Buontalenti's designs
18 for the costumes in *Intermezzi* – or the recording of scientific
information. But as the British became the main travellers
abroad, they encouraged the growth of topographical drawing;
it was part of the patronage of the Grand Tour not only to

acquire paintings by the chief Italian masters, but also to bring back views, more or less embellished, of the antiquities which were one of the objects of their journey. A fascinating example of this aspect of collecting is to be found, uniquely preserved, in the Cabinet at Felbrigg in Norfolk. On the walls of this grand salon are a group of twenty-six gouaches by Giovanni Battista Busiri of scenes near Rome, brought back by William Windham when he returned from Italy in 1742. Windham's tutor and companion on this Grand Tour, Benjamin Stillingfleet,

19

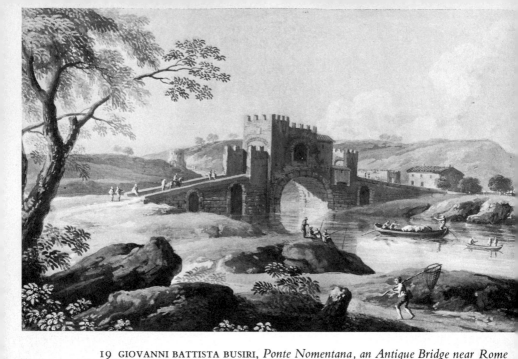

19 GIOVANNI BATTISTA BUSIRI, *Ponte Nomentana, an Antique Bridge near Rome*

described Busiri as 'one of the first masters of drawing landscapes with the pen'.

As Venice became one of the principal centres of interest, the drawing of landscape was greatly encouraged there by the patronage of foreign visitors. Consul Smith acted as entrepreneur for a number of English collectors. Of the artists in his circle, Marco Ricci extended the range of gouache landscape painting by producing some of his compositions, of ruins and classical buildings, in tempera on leather. Canaletto, whose visits to England between 1746 and 1755 had such a profound effect upon the nature school, preferred to make his *veduta* drawings with a lively pen outline washed with brown and grey. Francesco Guardi used watercolour infrequently, and the great number of repetitions of his Venetian scenes in gouache which so delighted the tourists were mainly made in the nine-

teenth century by his son Giacomo Guardi. Francesco Zuccarelli 20
became so fully acclimatized in England that he is usually re-
garded as a member of the British School, but he had produced
his decorative, somewhat artificial compositions of gay
peasants in mountainous scenery for many years in Italy.

That the tradition of English patronage of Italian draughts-
men was continued to the end of the eighteenth century is
shown by the career of Giovanni Battisti Lusieri, whose works
were sought by visitors to Naples in the 1780s. It was Sir
William Hamilton's recommendation which gained him his
appointment as Lord Elgin's draughtsman at the end of the
century.

20 FRANCESCO ZUCCARELLI, *Market Women and Cattle*

For a long time in France no attempt was made to distinguish between watercolour and gouache, and indeed the word *aquarelle* for watercolour was hardly introduced before 1775. For the French these were media for rapid record, mirroring the elegant urban life of the age of absolute monarchy. The most highly regarded painters rarely exhibited coloured drawings, but the technique spread rapidly, largely as a rich amateur's pastime, toward the end of the eighteenth century. The earlier days present the familiar and heterogeneous mixture of designs for the applied arts, scenes of daily life and landscape. There are few finer designs for the theatrical costumier than those produced by Henry Gissey. As 'Dessinateur de la Chambre et du Cabinet du Roi' it was in his province to invent the dresses for the Royal Ballets, including the dazzling costumes worn by his patron Louis XIV. Adam Frans van de Meulen brought from Flanders a familiarity with watercolour which he used for his sketches for battle paintings glorifying Louis XIV's campaigns. Israel Silvestre, an associate of Callot and Stefano della Bella, travelled widely and recorded the appearance of Rome in the middle of the century in a style which easily lent itself to his etcher's outline.

As the Goncourts said, the eighteenth century in France was the century of the vignette. The delectable *petits maîtres* who embodied the spirit of the rococo were encouraged to remain primarily draughtsmen by the increasing demand for book illustration, for engraving and for fashionable luxury products such as decorated snuffboxes and *étui*. Charles Eisen and Moreau le Jeune are two of the masters of small drawings of high life, peopled with many figures, which this taste promoted. Moreau's famous designs for *Le Monument du Costume*, a magnificent series ostensibly showing the costume of the 1770s, but in fact treating social situations such as a visit to the box of a theatre or a young mother's 'Declaration de la Grossesse', are drawn in pen and wash. But other designs by him and the illustrators who were his contemporaries are washed with watercolour. The most outstanding is Gabriel de Saint-Aubin.

32

21 JEAN-HONORÉ FRAGONARD, *The Marmot; Rosalie Fragonard in Savoy Costume*

22 GABRIEL DE SAINT-AUBIN, *Fête du Colisée*, 1772

22 His delighted observation of Parisian life gave rise to a multitude of drawings, many coloured with the delicately transparent tints which reflect the gaiety and elegance of the *belle monde*. His exuberance led him to decorate sale and exhibition catalogues with thumbnail sketches; and he records the galleries of the Salon and the rapidly growing art trade in France. At the same time, his management of light recalls Rembrandt and looks on 23 to Daumier. Niklas Lavrience made the drawings for well-known engravings of indiscreet scenes with erotic overtones in the heavier medium of gouache. Many of these are on vellum or ivory, and lie on the borders between the drawing and the miniature, as do those of Charlier and Baudouin. Intimate domestic scenes were also subjects for a number of other French

34

23 NIKLAS LAVRIENCE, *La Leçon de Clarinette*, 1784

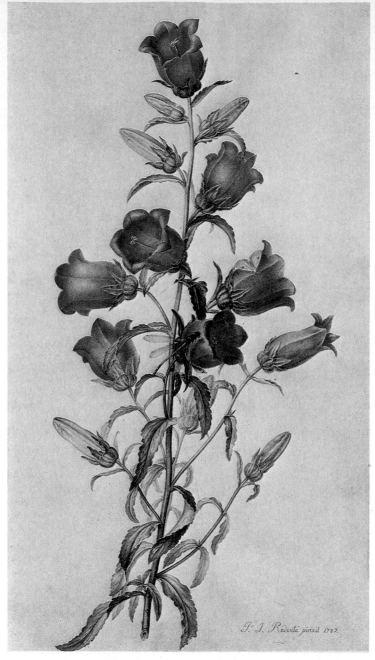

24 PIERRE-JOSEPH REDOUTÉ, *Canterbury Bells*, 1787

watercolourists, among them J. B. Huet, Mallet and Debucourt. Carmontelle made a reputation by his profile portraits of people in society, the most notable of which was of Mozart when a child prodigy.

The sophistication of Court life had as its contemporary antithesis the search for country scenes, and the supposed purity of nature and the life led in the fields. So an art of landscape was born again in the eighteenth century in France, though an artificial one in comparison with the directness of Poussin and Claude. Constable says of a landscape by Boucher: 'From cottages adorned with festoons of ivy, sparrow pots, etc. are seen issuing opera dancers with mops, brooms, milk pails, and guitars. . . . The scenery is diversified with winding streams, broken bridges, and water wheels; hedge stakes dancing minuets and groves bowing and curtseying to each other; the whole leaving the mind in a state of bewilderment and confusion, from which laughter alone can release it.' In large measure this search for nature took the exponents of open-air sketching to Rome, where the landscape, the antiquities, the society of fellow artists and the influence of the French Academy in that city acted as a magnet. Landscape drawings by Fragonard and Hubert Robert have much the same quality whether water- 25 colour is employed in them, or monochrome washes alone. Their efforts in this direction were controlled largely by the activities as entrepreneur of the Abbé de St Non, himself a distinctive aquatint engraver. St Non engaged a whole team of draughtsmen, Cassas and Claude-Louis Chatelet among them, for his *Voyage Pittoresque à Naples et dans les deux Siciles*, of which the first parts appeared between 1781 and 1786. But the artist in this circle whose life's work is most vividly bound up with watercolour is Louis-Jean Desprez. The two marked 26 divisions of his life are the years he spent in Italy (1776–84) and the later years in Sweden (1784–1804). His style is that of the tinted outline: a preliminary vivacious drawing in pen, in the areas defined by which the transparent local colour has been applied in broad washes. It is a sufficient indication of its quality

37

to note that there are a number of etchings of the outlines alone, which have been coloured by hand and make almost as brave a show as the more rigorously pure drawing. (In the British Museum Print Rooms four such outline etchings washed with colour are 'kept with the drawings'.)

The drawings for St Non's project were perceptively picturesque renderings of a land little known and travelled in; in Sweden, much of his work involved theatrical designs for the theatre at Drottningholm.

Desprez's career illuminates one aspect of the late eighteenth-century artistic life. A Frenchman, he found patronage and the impetus for his creative work abroad. In his case it was first in Italy and secondly in Sweden: but the exchange of ideas among cosmopolitan artists in Rome greatly hastened his development. That Rome acted as a meeting place and a challenge is

25 HUBERT ROBERT, *View of the Villa Madama*, 1760

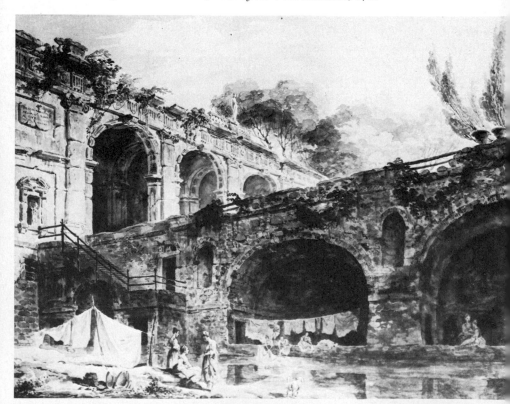

26 LOUIS-JEAN DESPREZ, *Ruins of the Temple of Hercules at Agrigentum*

seen not only from his experience, and that of English artists
discussed in the next chapter, but from his French contemporary,
Charles-Michel-Ange Challe. He fell under the spell of
Piranesi, and produced his dark, sombre drawings of archi-
tectural fantasies under his shadow. Desprez himself made a
drawing of the interior of St Peter's, with the Cross spectacularly
lighted, which Piranesi etched.

The two trends, the topographical and descriptive by artists
who took their subjects from their homeland, and the romantic
and exotic from those who travelled, are exemplified once
more in later eighteenth-century Swiss drawings. Regional
artists, such as Sigmund Freudenberger, treated Cantonal life in *29*
the charming and slightly artificial manner we associate in oil
painting with Berghem and in watercolour with Zuccarelli.
Johann Ludwig Aberli has a more direct approach to the natural *27*
beauties of his country. Switzerland, with its dramatic beauties,
was one of the first countries in which the love of nature led

27 JOHANN LUDWIG ABERLI, *The Waterfall*

28 ABRAHAM LOUIS RODOLPHE DUCROS, *Orage Nocturne à Cefalou, Calabre*

artists to paint and patrons to buy representations of mountainous scenes. The heady developments of the *Sturm und Drang* movement led a number of them to escape from the paternal liberty of the Cantons. Many went to England – Grimm, Fuseli, de Loutherbourg among them. But the most original of all in vision, Abraham Louis Rodolphe Ducros, left Geneva in 1770 for Flanders and travelled thence to Rome in 1772. The question of what influence he had on the English watercolourists who were at Rome in his time is a recent one, either shirked or unsolved. But it is certain that he derived, probably from Piranesi, a type of vision and a method of perspective which enhanced the apparent size of his subject and increased its Romantic effect. The medium of his basic work was watercolour; he used a limited palette, based on blues and blue-greys and heightened in places with gum. These works were made on a relatively

29 SIGMUND
FREUDENBERGER,
*La Toilette
Champêtre*, 1781

large scale and were so forceful in tone that they could stand being framed close to the edge in broad gilt mouldings. This made it possible to hang them side by side with oil paintings, a feature which became of increasing importance in the mixed exhibitions and collections of the late eighteenth century.

Ducros sold some of his watercolours; a number found their way into the collection of Sir Richard Colt Hoare at Stourhead, who greatly admired them. But mainly the artist retained them, in order to use them as the source of outline engravings which he sold to visiting collectors. It was envy of his success in this trade, and anger at his refusal to sell them the originals which caused some of his fellow artists to help to chase him from Rome at the time of political troubles in 1793, six years before the collapse of this phase of life in Rome upon its occupation by the French.

These political events also led to the retreat of Philipp Hackert from Naples to Florence. Hackert was the most renowned German exponent of landscape in the eighteenth century, and had begun with a roving career, like many of his French, Swiss and English counterparts. He was born in Brandenburg in 1739, and studied at the Berlin Academy under Le Sueur, who turned his mind towards landscape. After a visit to Stockholm in 1764 he went to Paris. Here he learned to use gouache, then coming into fashion as a medium in France. While there he formed a friendship with Samuel Hieronymus Grimm, a *41* Swiss artist who was about to settle in England. That these two artists should, in company with Nicolas Pérignon, have gone on a walking tour through a large part of France, sketching picturesque places, is just one example of the increased awareness of nature, and the Romantic approach to scenery, which was growing throughout Europe in the middle of the eighteenth century.

Soon after this, in 1768, Hackert settled in Rome and spent the next thirty years based there or in Naples. Here he established himself as the arbiter of taste in landscape, adopting in particular a lofty tone towards the English artists in Rome whom he

43

judged too dependent on Poussin and Claude and not suffi-
ciently imbued with the original spirit he claimed for his own
work.

He was highly regarded in his own time, and prolific in water-
colour, gouache and washed drawings as well as oil paintings of
subjects drawn from the standard themes of the Italian country
dignified by ruins. Goethe, himself a highly capable amateur
draughtsman, learned from him and wrote his life from the
papers he left. But not everyone was impressed. Thomas Jones,
the pupil of Richard Wilson, met him in Naples in 1782 and the
remarks he made in his journal are far from enthusiastic. He
records Hackert's praise of his own improvement 'in paying due
attention to the *Detail* – that is to say, minute finishing, which
by the bye, was more congenial to his own taste, who like most
German Artists, study more the *Minutiae* than the grand
principles of the Art.' Then he adds: 'I may here observe that
there never was, perhaps, a man who was more endued with the
Talent of making People believe that he was the greatest genius
that ever existed. . . . Posterity will more impartially judge of
his real merit.' Posterity has judged by consigning him to fairly
comprehensive oblivion. But he was of importance as a judge to
whom people deferred. The social evenings he held, at which
groups of amateurs made drawings, were evidently charming
to those who took part in them. They are another evidence of
the growth of sensibility, and a foretaste of the Sketching Clubs
which sprang up in England from the 1790s to foster the applica-
tion of poetic feeling to painting. Hackert was much in demand
with English visitors to Rome, and in 1777 toured Sicily as
draughtsman for Richard Payne Knight.

The course of botanical painting in the eighteenth century is
best seen in the work of its two greatest exponents, George
Dionysius Ehret and Redouté.

30 Ehret, who was born in Heidelberg in 1708, lived and worked
in England from 1736 till his death in 1770, a dominant figure
equally through the excellence of his work and by the number
of his pupils and followers. He preferred making his most

44

studied flower paintings in bodycolour on vellum. Pierre-
Joseph Redouté, who was born in the Ardennes in 1759, was
much impressed by the work of Jan van Huysum when he
visited Amsterdam. Then he went to Paris in 1782. At the
Jardin des Plantes he fell in with the Dutch-born Gerard van
Spaëndonck, a follower of van Huysum, and from him he
learned the sources of his own virtuosity. His greatest work was
done in France, and its summit, *Les Liliacées* (1802–16) and *Les
Roses* (1817–24) belong to the Napoleonic and post-Napoleonic
era. His watercolour drawings of plants are exquisitely rendered
in transparent washes on vellum. But the wider proliferation of
his work was due to his mastery of the medium of colour
stipple engraving. He had learned the outlines of this method
when in England and developed it into a perfect instrument for
multiplying his images. This is one example among many of the
close dependence at this time of the watercolour painter upon
the engravings made from his work.

24

45

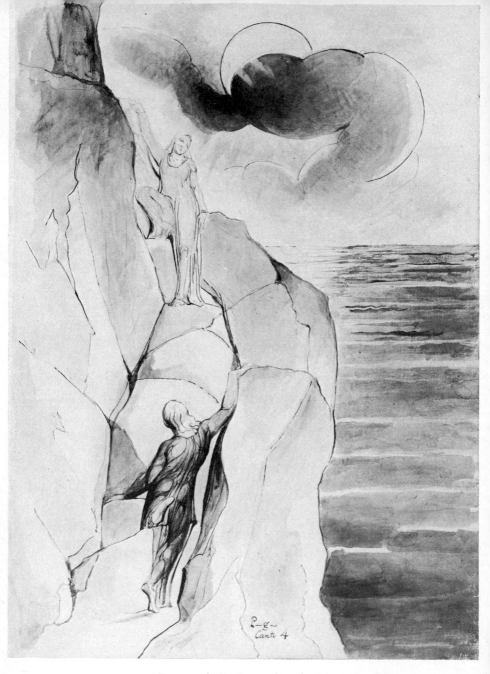

31 WILLIAM BLAKE, *Dante and Virgil ascending the Mountain of Purgatory*, 1824–27

British watercolour to the end of the eighteenth century

It is against the background lightly sketched in the foregoing chapter that the growth of watercolour painting in England has to be considered. The English School is of more recent origin than those of the Continent, and only derived its own identity after a long period of apprenticeship.

None the less, the first appearance of the word 'watercolour' recorded in the *Oxford English Dictionary* comes from Shakespeare and is contemporary with the work of John White and Le Moyne de Morgues. Though this quotation from *Henry IV, Part 1*, suggests a rather pejorative view:

> *And never yet did Insurrection want*
> *Such water-colours to impaint his cause . . .*

the straightforward usage of the term was well established in the seventeenth century.

To begin with, the pattern is much the same as in France or Holland; outside the tradition of the illuminated manuscript there are sporadic uses of watercolour as an adjunct to monochrome drawing from the beginning of the sixteenth century till the middle of the eighteenth century. Then a continuous flow set in, different in quantity and almost for that reason alone different in kind from other schools. The distinctive nature of this development became evident when the English showed a section of 114 watercolours at the Exposition Universelle in Paris in 1855. It was the first time painting had been a feature of such international exhibitions, and the watercolours were immediately seized on by the French critics as a special case. For instance, Edmond About wrote on the English section: 'I can pass without transition from oil to watercolour paintings; these two genres are less distinct in England than with us.

More than one English painting presents the paleness and the faded grace of the watercolour; more than one watercolour has the vigour of an oil painting. Watercolour is, for the English, a national art.' After announcing to his doubtless surprised readers that there were two watercolour societies in London devoted to promoting the sale of the members' work, and pointing out that this medium, willingly left in France to girls' boarding schools, is used by British artists of the first rank, he imagines a conversation with an English supporter of the system. Why, says the *advocatus diaboli*, make spirited sketches in watercolour when it would be so much easier in oil? Will not the watercolour perish, profitable though it is at the moment? The defendant retorts that the method has been practised in England for a century and is the traditional mode. At which the critic gives up: 'I do not argue with national pride, above all not with the English.'

This account, humorously set out, shows to what an extent the deliberate use of watercolour as a medium for finished works was an apparent feature of English art by the middle of the nineteenth century. The same observation was made by more sympathetic observers; Baudelaire, for instance, in the notes he made on the 1855 exhibition, commented on the 'Scottish verdures, magical visions of freshness, receding depths in water-colours as vast as stage-decorations, although so small.'

It is the prime justification for the existence of nations and national schools of art that such marked differences can grow up. The creation of the watercolour in English painting, so noticeable to French critics in 1855, when they were confronted with it *en masse*, was the product, almost in isolation, of the previous hundred years. The first, sporadic instances of watercolour drawing in the late sixteenth century by John White and Le Moyne de Morgues were called forth by the requirements of scientific delineation of the natives, flowers, fruits and birds of unknown regions. The few costume designs by Inigo Jones for masques which are coloured are devised as directions to the maker of the costumes.

48

The topographical delineation of England forms an important ingredient in the events which led to the national school of landscape. The most notable forerunners of the sixteenth century were both Flemish; Anthonis van den Wyngaerde, who worked there about 1560, and Joris Hoefnagel about ten years later. The next important event does not take place till 1636, when Wenceslaus Hollar came to England to work for Lord Arundel. Hollar was born in Prague and received his main training in Germany. His views follow the established tradition of a panorama sketched from a low view-point, though they have, as Lord Arundel said, a 'pretty spiritte'. The recently discovered drawings made in England by Willem Schellinks, Jacob Esselens and Lambert Doomer in the early 1660s show the application of the mature Dutch style to the same kind of material. While the latter are generally only washed with brown and grey, Hollar's are at times lightly tinted with watercolour. The Dutch visitors, working for a private patron, had little direct effect on English art. Hollar, on the other hand, had a disciple in Francis Place whose views also are sometimes washed *32* with watercolour.

The theme of topography, the description of interesting places without the intrusion of strong personal comment, was continued in the early eighteenth century. The Dutch artists Leonard Knyff and Johannes Kip were joined by the English-born brothers Samuel and Nathaniel Buck in this enterprise; but in all these cases the artists' work belongs to the history of drawing, not watercolour.

It is interesting to consider the varying reasons and motives which led to the production of such drawings. They come from an increasing interest in other towns, and views of special note. Hollar was employed by Lord Arundel to record the places he visited on his travels. Later he made drawings as the basis for engravings which would have a wider circulation. Schellinks and his companions were engaged on the purely private mission of contributing to the Atlas which was being compiled on a grand scale in Amsterdam by Laurens van der Hem, as a visual

49

record of much of the accessible world. The prime object of the Buck brothers was to provide the material for a large series of engravings of national antiquities; these were bought in large quantities for the collections in country houses, but in essence their motive was to publish for as wide a market as possible. The English are the most narcissistic of races, as their fondness for portraits shows; and from the seventeenth century onward they wanted views of their houses as well as of themselves and their horses.

The idea of the artist working solely for his own entertainment was slower in gaining acceptance. Still slower was the plan, later almost universal, whereby the artist produced his drawing without reference to a commission or an existing patron, and placed it on sale at public exhibitions. It was the growth of these outlets which encouraged the free expression of

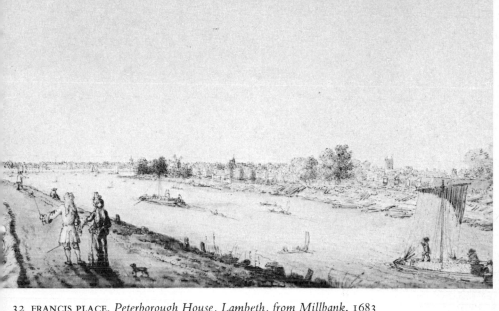

32 FRANCIS PLACE, *Peterborough House, Lambeth, from Millbank*, 1683

the artist's personality in his work, a feature so characteristic of Romantic art.

The personal note is already marked in the comparatively infrequent watercolours of Samuel Scott. He contributed to the *Five Days' Peregrination*, a light-hearted diary of a journey undertaken down the Thames in company with Hogarth and Thornhill. The manuscript record of this trip is notable because it contains some of Hogarth's few excursions into drawings washed with colour. Beyond this special private chronicle, Scott's drawings either reflect his concerns as a sea painter or are straightforward representations of localities, such as Twickenham on the Thames. Sir James Thornhill was the mentor of these artists. The father-in-law of Hogarth, he himself had kept an illustrated travel diary of his journeys to the Low Countries and to France, though here the drawings are made with the

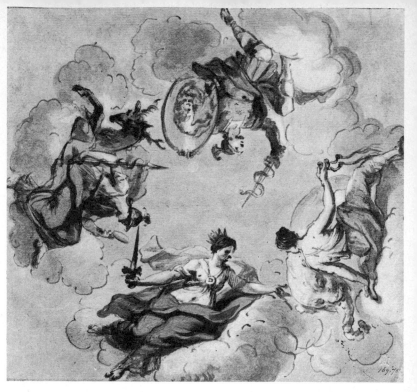

33 SIR JAMES THORNHILL, design for a ceiling *The Four Cardinal Virtues*

33 pen. As the leading English exponent of Baroque mural decoration his mind teemed with ideas for compositions on classical or religious themes. Many of these remained pen drawings; but an important group are delectably embellished with watercolour washes, and designed to serve as models for the finished work in the fashion we have already encountered with Jordaens.

Not even the use of water- or bodycolour in the early eighteenth century by Thornhill, Hogarth and Scott would justify us in talking of an English tradition in the medium at that time. The really continuous process begins near the middle of the eighteenth century; and two of its earliest representatives are William Taverner and Paul Sandby. Both worked for preference

in watercolour or bodycolour; both produced a substantial body of work in these media; both were stay-at-homes; both were greatly admired in their time. There the resemblances end.

William Taverner was, or claimed to be, an amateur. He was most reluctant to show his drawings, a foible which increased their desirability. In the main he was re-interpreting, for his own times, the compositions of Poussin; a method pursued by his contemporary George Lambert in oil painting. But just as he had two media, bodycolour and the transparent medium, so he had two types of subject-matter. One is the landscape composition put together on classical lines – 'classical' meaning, in this context, in accord with Poussin's example. The other is a more factual account of places seen, though even here, as in his views of Hampstead, the idea of a sacred grove transmitted from *34*

34 WILLIAM TAVERNER, *Hampstead Heath,* 1765

classical literature through seventeenth-century landscape painting is in evidence. Whatever his diffidence and shortcomings, Taverner was highly praised by Smollett; but his acute sense of privacy prevented his having a great effect on the development of the art.

35–6, 50 But while Taverner was a private man, Paul Sandby was emphatically a public man. He took a leading part in the agitations, which are the focus of the art politics of eighteenth-century Britain, for the foundation of an exhibiting society of artists. This led, as is well known, to the establishment in 1769 of the Royal Academy, of which Paul Sandby was a foundation member. Sandby's firm support of the proposals for artistic cooperation led him to quarrel with Hogarth who, in spite of his British chauvinism, opposed these plans.

36 In his art Sandby was an eclectic. There is a logical sobriety about his town scenes which associates him with the Dutch draughtsmen of the seventeenth and eighteenth centuries. But in these scenes the action of the figures is of unusual importance. They are not just staffage put in to fill up the spaces, but are studied with an interest in character and action quite appropriate to the age which saw the birth in England of the anecdotal novel. When he drew individual figures the impress of French elegance brought over to the country by Gravelot is apparent. Further, although he never went to Italy, there is a strong impress of Italian taste about his style. It comes out in the more contrived compositions he thought of as his most important work, in which the straightforward appearance of a stretch of landscape 50 such as Windsor Great Park or the Welsh Hills is transformed by the imposition of a framework derived from Claude, Poussin or other seventeenth-century source. These more ambitious pieces were often carried out partly or wholly in bodycolour, for though Paul Sandby is often called the 'father of English water-colour', he felt no exclusive loyalty to the more transparent medium.

The sources of the Italianate approach in Sandby are an interesting commentary on the cross-currents in English taste in

54

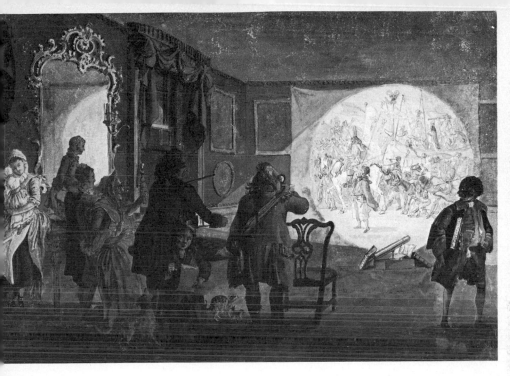

35 PAUL SANDBY, *The Magic Lantern*

the mid-eighteenth century. The fondness of travellers on the
Grand Tour for gouaches by Busiri and Marco Ricci was one *19*
element; Sandby himself possessed drawings by Ricci. The
growing movement of British artists to Italy was another
factor; although he did not join in their travels Sandby was
associated with many of its leaders and himself made aquatint
engravings of Italian scenes after David Allan, William Pars, *47*
Clérisseau and Fabris. By amalgamating these elements through
the force of his own temperament, and by concentrating on
watercolour drawing and on engraving – he rarely painted in
oil – Sandby created the norm for half of the watercolour paint-
ing of his time. He created its public also, and his success is most
clearly understood through the praise and patronage he received.
No artist could have received a more handsome tribute than he

when Gainsborough wrote in about 1764 to a client who wanted a landscape from him: 'With respect to real Views from Nature in this Country he [Gainsborough] has never seen any Place that affords a Subject equal to the poorest imitations of Gaspar or Claude. Paul San[d]by is the only Man of Genius, he believes, who has employed his Pencil that way.' That Sandby should become a founder member of the Royal Academy gave watercolour painting its official standing at an important moment.

The style he evolved remained current for three or four decades and is notable mainly for its common sense, and absence of excess. It is the style of the stay-at-home artists, who did not make the trip to Italy or fall under the spell of the Swiss Alps. But to the dry descriptive topographical record of Knyff or the Bucks he has added that element of poetry which gives the young British landscape school its lyrical quality. Much of Sandby's work is centred round Windsor Castle, and Windsor Great Forest, where his brother Thomas, a far less interesting watercolourist, held the official position of Ranger. That this response to the great old trees of the past, and to the medieval fabric of the Castle was an emotional one can be felt from the countless drawings he made of these subjects. He also provides an early instance of that responsiveness to atmosphere which the sheer facts of life in England encourage: in particular, the view into a gorgeously coloured red and orange sunset, casting long shadows on the evening ground is one which he desires to render again and again. He brings a fresh eye to the play of light in the leaves and branches of trees, no less than on the distant hills of Wales. He dominated the style of the indigenous artists for half a century; so long that he had fallen out of fashion before he died in 1809. It had been his personal felicity to interpret the English scene of his time in the way most acceptable to his patrons. By choosing as his natural subject the groves and perspectives of Windsor, in place of the formality of the park of a country house, he set a happy precedent for informality.

The unpretentious normality and the unostentatious virtuosity of Sandby's manner became the dominant mode for water-

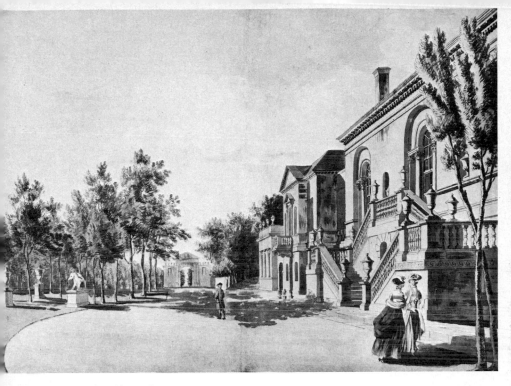

36 PAUL SANDBY, *Chiswick House*

colour of English scenes by English artists for the remainder of
the eighteenth century. It is not surprising that it should be
marked in the work of Michael Angelo Rooker, since he was *37*
Paul Sandby's pupil. His record of the countryside and its
towns is a straightforward one which does not include any of
the Italian graces which Sandby sometimes introduced. Yet
there was a more dramatic side to his career, for he was scene
designer for the Haymarket Theatre, and known in that pro-
fession by the Italianate name of Signor Rookerini. Such exotic
touches are to be found in the most unlikely directions. Thomas
Hearne distilled the pure prose of the eighteenth-century scene *39*
into drawings for the engravers and his work was admired in
the 1790s by Dr Monro even above that of the young Girtin and
Turner. By no stretch of the imagination can he be regarded as

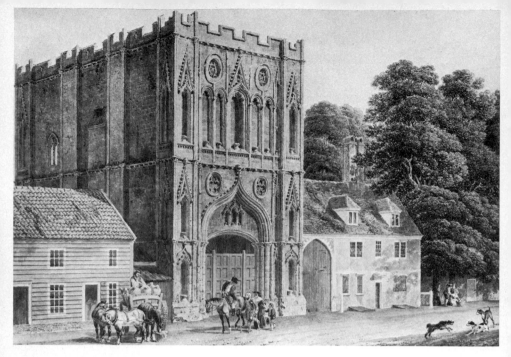

37 MICHAEL ANGELO ROOKER, *Gateway of the Abbey, Bury St Edmunds*

having added any marked personal note to the formula which had been naturalized by Sandby. Yet he too had his taste of distant travel, when he accompanied the Governor of the Leeward Islands as his draughtsman.

Paul Sandby had been helped in his drawings of buildings by the architectural skill of his brother Thomas. A similar ability in fitting the facts of a townscape into the mathematical rigidity of the perspective grid is seen in the work of the two Thomas Maltons, father and son. Thomas Malton senior wrote a
38 standard textbook on perspective; his son taught the subject to Turner, and he in his turn used Malton's book as a basis for his lectures as Professor of Perspective in the Royal Academy.

The pressure of patronage in England could impose itself upon the visiting artist as much as on the native one. Samuel

58

39 THOMAS HEARNE, *St John's, Antigua*

38 THOMAS MALTON, JUNIOR, *North Parade, Bath*, 1777

41 Hieronymus Grimm, as we have seen, began his career as a wild young member of the Swiss *Sturm und Drang* movement. But after he reached England his emotional transcriptions of mountains and precipices became muted. His mode of expression turned to the vernacular, the rendering of country folk in country places with an approving eye on the trees, the buildings and the people. The only comment he allows himself is in the mild satire of such drawings as *The Macaroni*. But not all the Swiss painters who came to England felt the same need to con-
40
52 form to the consensus. Philip James de Loutherbourg and Henry Fuseli were initiators of the real Romantic trend in British art at the end of the century. De Loutherbourg was also an innovator in the theatre and in landscape, Fuseli in poetic illustration and his interiors with fantastically dressed women.

There is not necessarily an exact corollary between a novel subject-matter and a novel technique. The cult of ruins is one

40 PHILIP JAMES DE LOUTHERBOURG, *Cataract on the Llugwy, near Conway*

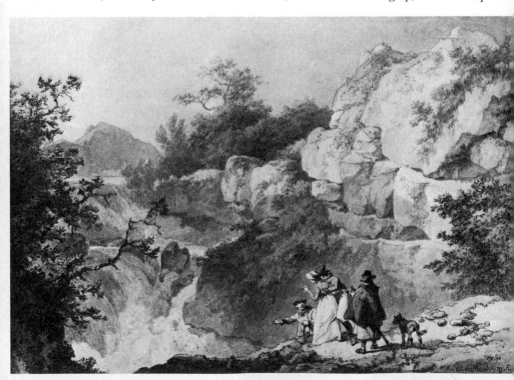

41 SAMUEL HIERONYMUS GRIMM, *Mother Ludlam's Hole*, 1781

essential ingredient of the picturesque, and prevalent in the Gothic novel of Walpole and Mrs Radcliffe, no less than in Romantic painting. But ruins could be described through the measured formality of Augustan poetry in Thomson's *Seasons*, a poem which fired the imagination of most important painters at the end of the eighteenth century. Equally, Paul Sandby, Michael Angelo Rooker, S. H. Grimm and Edward Dayes all made watercolour drawings of venerable old buildings – the antiquities about which so many publications were being made – with the same formal elegance as they applied to the new Georgian buildings of their own time. It was Paul Sandby's great achievement to have imposed this style for nearly half a century, and its break-up led to the second stage of the English manner in watercolour.

37

Working at the same time as this group of artists who made the domestic scene their main subject were a number of equally gifted watercolourists whose travels in Europe dominated their work. For most of them the goal of their journey was Rome; most important formative influences being their view of the Swiss and Italian Alps on their journey, and the stimulus of the international society of artists they met on their arrival in Rome.

A look at the dates will make the latter point clear. G. B. Piranesi, a primordial originator of the Romantic spirit, arrived in Rome in 1740. He was patronized by Lord Caulfield and elected a Fellow of the Society of Antiquaries in 1757; his operations in Rome lasted till his death in 1778. C. M. A. Challe arrived as a Rome scholar in 1742. Alexander Cozens, a great originator in English drawing, though he rarely used watercolour, was in Rome in 1746. Richard Wilson learned the mastery he applied to English landscape painting during his visit to Rome from 1752 till 1755. The Frenchmen Hubert *25, 21* Robert arrived in 1754 and Fragonard in 1756. The next notable arrival from England was the young man Jonathan *43* Skelton, who reached Rome in 1758 intending to further his studies in watercolour painting, but died 'an unhappy victim to a laudable ambition' early in the following year. The German Philipp Hackert, who was such an arbiter of taste, reached Rome *28* in 1768. Ducros arrived from Switzerland in 1772, but as we have seen, affronted other artists by limiting the sale of his original drawings. The year 1776 saw the arrival of the Abbé *26* St Non's collaborator Desprez and of Richard Wilson's Welsh *51* pupil, Thomas Jones. The latter recorded in his *Memoirs* the *47* presence in Rome of William Pars and the arrival of John *44–6* Robert Cozens on his first visit in the train of William Beckford, *42* his eccentric millionaire patron. With John Warwick Smith (said to have been there between 1776 and 1781) and Francis *49* Towne who arrived in 1781, the tally of the more significant British painters to reach Rome in the eighteenth century is complete.

42 JOHN WARWICK SMITH, *Church of La Trinità del Monte, Rome*

43 JONATHAN SKELTON, *Tivoli*

That the combined effect of the Alpine scenery they had passed through on the way, the historical associations of the monuments of Italy and the example of their fellow artists had a stimulating effect on this group is evident from their work. Even John Warwick Smith, whose natural bent was for a pedestrian delineation even of the mountains of the Lake District and Wales, had his imagination fired by his stay in Italy. Whilst there he copied a sketch by J.R. Cozens, and he travelled back to England through Switzerland in the company of Francis Towne. These associations led to his developing a broader manner beside that of the worthy but unexciting topography of his stock style. Most of the examples of this freer manner are of Italian scenes – for instance, the *Falls at Tivoli* in the Victoria and Albert Museum and the *Ambulatory of the Colosseum* in the British Museum.

Alexander Cozens' part in this was not directly concerned with watercolour. 'As full of systems as the universe', he compiled a pamphlet on the use of a palette of thirty watercolour pigments; but in practice he used black and grey washes. The originality of his style consists in its suggestiveness; and in his ability to evoke both form and atmosphere from a severely limited range of brush strokes. To many people they recall Chinese drawings, and he may have seen specimens of Oriental art in Russia and on his subsequent travels. As a close friend of William Beckford he was an associate of a leading protagonist of the trend toward sensibility of feeling in late eighteenth-century English life; one, moreover, whose great wealth enabled him to indulge his tastes to the full. Beckford's tutor in music was Mozart and in drawing Alexander Cozens.

44–6 John Robert Cozens owed his technical skill to his father's training, but the wholly individual strain of poetry in his watercolour painting did not make itself apparent till his first visit to Switzerland in 1776. He paid this visit, it seems, in company with another rich dilettante, Richard Payne Knight, and he reached Rome in December of the same year. On his visit of 1782 he was in the suite of William Beckford. Thomas Jones

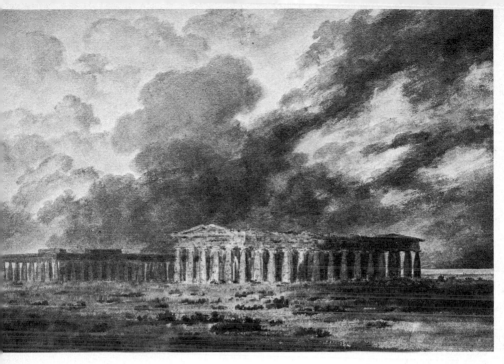

44 JOHN ROBERT COZENS, *Ruins of Paestum*, 1782

noted in his *Memoirs* that when Beckford left Naples for
Marseilles, he left Cozens behind, 'once more a free agent and
loosed from the shackles of fantastic folly and caprice'. The
result of these travels was that Cozens acquired a vast repertoire
of the more grandly picturesque subjects, extending from
Switzerland to the Roman Campagna. He made repeated
versions of many of the most popular themes, so that there are a
number of replicas of, for instance, his views of Lake Albano,
and Lake Nemi. His range of subjects includes the Villa d'Este,
Tivoli and Paestum, and he worked from the drawings of
amateurs such as Charles Gore, infusing into their sketches his
own sense of style.

There are few closer examples of landscape as the expression
of a personality than the hauntingly direct watercolours of

65

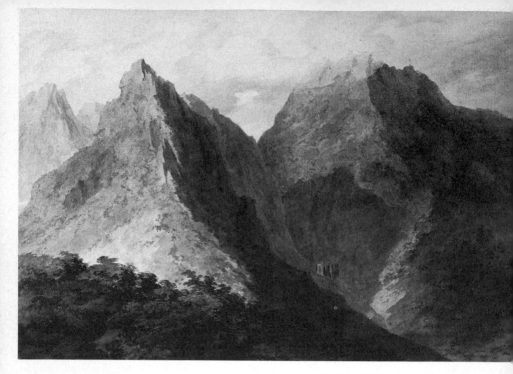

45 JOHN ROBERT COZENS, *Mountains on the Isle of Elba*, 1780/89

John Robert Cozens. Even if we did not know that he went mad shortly before the end of his life we should have been in no doubt about the strain of melancholy in his painting. Like the poet William Collins, who also lost his reason, his work is a constant 'Ode to Evening' and he looks everywhere to see those:

> *. . . dewy fingers draw*
> *the gradual dusky veil.*

He even finds the melancholy of approaching twilight in Naples, which Turner was later to see as a riot of colour in the Mediterranean sun. His subject is as much the great expanse of sky, out of which the colour is ebbing, as the ground below; and his greatest skill lies in his understanding, and management, of

66

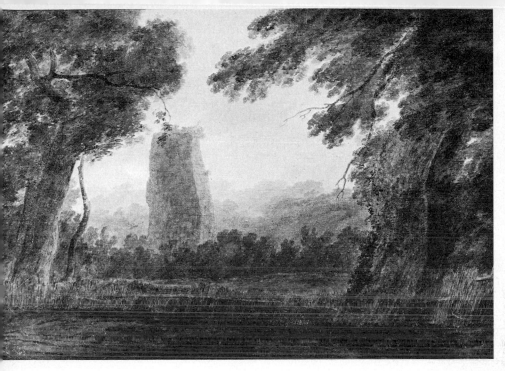

46 JOHN ROBERT COZENS, *On the Strada Nomentana, Rome*

light. The way he modifies his local tones with grey puts all the elements of his landscape into keeping with one another.

Thomas Jones, to whose *Memoirs* we owe so much of what 51 we know about the circle of artists in Rome in the 1770s and 1780s was, as a pupil of Richard Wilson, mainly a painter in oils. But he inaugurated an interesting series of events in Naples when he 'began several studies of the different scenes and objects seen from the windows on both sides, some of which were painted in oil, and some in watercolours'. The few examples we know of these early instances of *plein-air* painting are distinguished by their fresh colour, notably an uninhibited use of blue, and the sharp light falling on the landscape.

One of Jones' closest friends in Rome was William Pars. He 47 lodged in the same house, 'set up housekeeping in partnership

and as we were both heartily sick of the Italian soups and stews, determined to live as much as possibly we could, in the English style'. Jones was one of these who tried to dissuade Pars from making watercolours of landscape and to turn back to the portrait-painting for which he had been trained. But, though he would sometimes, in a temper, call it a 'trifling employment' it is by his watercolours that he is remembered. He began his employment as a draughtsman of little-known places early in his career. The Dilettante Society sent him to Greece from 1764 till 1766. This mission was one of the first pieces of evidence of the reviving interest in the monuments of Attica, Argolis and the Peloponnesus which was to lead to the neo-classic revival in painting and the applied arts. When he went to Switzerland before 1771, Pars showed that he was fully alive to the grandeur of the mountain scenery, and possessed a strong sense of space. In Rome, where he lived from 1775 till his death in 1782, his style in watercolour matured, and was strengthened by his feeling for the venerable buildings which form the subject of many of his best drawings. There is a certain softness about these drawings; his colour is tasteful and reticent, and he draws freely with the brush without conspicuous outline.

49, 53 It was the acquisition by the British Museum of a number of William Pars' drawings which encouraged Francis Towne to bequeath a group of the watercolours he had made at Rome to that institution. But this generous act did not lift the veil of obscurity which had fallen on him long before his death in 1816. He had something of William Taverner's timidity, and once boasted that he had never exhibited a drawing in his life; though this is probably more a recognition of the inferior status he gave to watercolour in contrast to oil than a reflection of any uncertainty about the merit of his work in the medium. Wild places stirred his imagination, and the first mark of his original power is seen in the drawings he made in Wales in 1777 and 1778. The high point of his career was reached through the journey he made to Rome in 1780, returning through the Swiss Alps in 1781. Here he was with his friend Pars, and Thomas

68

47 WILLIAM PARS, *Italian Villa*

Jones made himself his cicerone at Naples. On one of their journeys to romantic places Jones was just saying 'we only want Banditti to complete the picture [by Salvator Rosa]' when they came upon three bandits cutting up a dead jackass. Towne, never conspicuous by his courage, decided to retreat, 'adding, with a forced smile that, however he might admire such scenes in a picture, he did not relish them in Nature'.

The companionship of Pars and Cozens in Rome, and the experience of the Swiss Alps, encouraged Towne in the personal novelties of his style. In place of the softness of Pars and the graded recession of Cozens, Towne's work is distinguished by its sharpness of focus. He achieves this by emphasizing the outlines – usually carried out with dexterous pen work – and by his ability in finding the way to cut off his image to give it a powerful

effect. The latter characteristic has been compared with the art of the Japanese print. It is unlikely that Towne ever received a conscious impetus from Oriental art. A hypothetical, but more probable, source for some of his ideas could be the widely dispersed engravings of Swiss scenes after such artists as Aberli. These possess both the sharp outline, distinctive of etching, and the flat washes, to which Towne has added his own capacity for cutting off a scene to the maximum effect. Whatever its origins, Towne's work in Rome and Switzerland and, to a lesser extent in Wales, communicates the authentic Romantic response to the sublime. How much he needed to be in those places of his inspiration, and to enjoy the close companionship of the contemporary leaders of English watercolour is shown by the decline in his work after his return to England. Settled in his birthplace, Exeter, on his return, he relapsed into being a provincial drawing master. The masterly work of his brief prime was not resurrected for a century after his death.

Not that provincial drawing masters were without influence or to be despised on grounds of inferior merit. J. B. Malchair, a Rhenish artist from Cologne, settled in Oxford about 1759 and exercised a strong influence from that city during the fifty-odd years he lived there. One part of his effect on the development of watercolour came from the teaching he gave to a variety of amateurs. The abundance of amateur talent for watercolour in Britain in the eighteenth and nineteenth centuries is a substantial reason for the strength of the professional work. Taverner could not decide whether he was amateur or professional. Men like Sir George Beaumont, Lord Aylesford and William Crotch – all pupils of Malchair – had talent enough to have pursued a professional career had their social standing not precluded it. As it was, the practical training they had received made them in the main perceptive critics of contemporary painting; and they were sympathetic to the growth of interest in atmosphere which was a leading characteristic in Malchair.

Though the Rev. William Gilpin was not a watercolour painter he must be mentioned for his far-reaching effect on the

style of watercolour. His series of guidebooks to the English countryside, illustrated with aquatints after his own drawings became the Bible of the picturesque. 'The picturesque' is a technical term of late eighteenth-century criticism, denoting a form of education in looking for specific features in landscape, features which had appeared in paintings by such proto-Romantics as Claude and Salvator Rosa. The theory became a tissue of arbitrary rules summed up in Sidney Smith's *mot*: 'The parson's horse is beautiful, the curate's horse is picturesque,' but it was so influential as to impose a virtual dictatorship on taste between 1780 and 1820. It will be recalled that the heroine of Jane Austen's *Northanger Abbey*, Catherine Morland, having received a lecture on the picturesque from Henry Tilney,

48 EDWARD DAYES, *Buckingham House, St James's Park*, 1790

49 FRANCIS TOWNE, *Larice*, 1781

'voluntarily rejected the whole city of Bath, as unworthy to make part of a landscape'. In a more general sense it led to the management of the physical features, mountains, trees, rivers and spaces and their amalgamation by a sense of light, so as to evoke a feeling – tranquil, horrific, exciting – from the country-side depicted. This doctrine, anticipated and excelled by the leaders such as Pars and Cozens, lies at the root of much nineteenth-century landscape in the manner of Varley.

Of the professional topographers, Edward Dayes marks the transition from the eighteenth to the nineteenth century. His main subject-matter is the picturesque ruin, treated in a tautly conceived palette of blues and greens which, at a brief moment in his early career, Turner closely imitated. Then there are the panoramas of social life in London of which *Buckingham House* is justly by far the best known. A well-conceived group of

48

72

50 PAUL SANDBY, *Road through Windsor Forest*

51 THOMAS JONES, *Lake Nemi and Genzano*

fashionable loungers in front of the building which is now Buckingham Palace gives a credible glimpse of the elegance of 1790. But there is yet another side to Dayes. He had a chronic irritability of temperament, and before committing suicide at the age of forty left a series of malicious commentaries on his contemporaries. The positive aspect of his wider ambition is seen in his subject pictures of medieval history, conceived in a strain of romanticism which has caused some of them to be confused with the earlier work of William Blake.

For, although all the British artists so far discussed have been landscape painters, this aspect of nature did not monopolize the entire attention of watercolourists at the time. Figure compositions were produced as illustrations, caricatures or expressions of ultra-Romantic sentiment; and the last, most characteristic, outcome arose in great measure from the illustration of medieval history. As well as being the age in which the effect of landscape on human sensibility was first explored to its depths, the eighteenth century was the period in which men more and more turned their eyes towards the past, in fascination or horror, but always with interest. The effect of this on landscape itself has already been seen in the fondness of Rooker, Hearne and Dayes for the ruins of castles and abbeys. It is equally apparent in the illustrated editions of English history and of English classics which were now produced. These forced the artists who were called on to illustrate them to make an attempt at rendering a dress alien to their age, and laid the foundations of the historical reconstructions of the nineteenth century. Much of the effort – the plates for Hume's *History of England* and of Boydell's *Shakespeare* – belongs to the history of oil painting, but the change in visual habit which they caused had its reflection in watercolour. Fuseli is the critical example of this. Another Swiss exile, he had brought to England his passion for literature, a range which included the Greek tragedies, the Norse 'Eddas', Shakespeare and Milton, and his somewhat fetishistic delight in the female costume of his epoch. All these are seen in his oil paintings for Boydell's *Shakespeare*

74

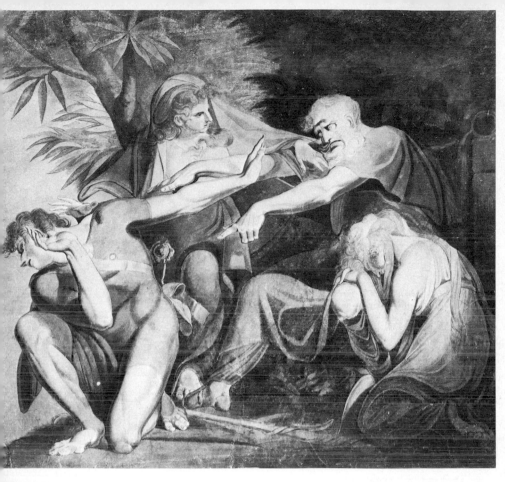

52 HENRY FUSELI, *Oedipus cursing his son Polynices*

and in his own *Milton Gallery*. In his watercolours he explores
part of the same universe; it is mainly the remarkable col-
location of the high head-dresses, low *décolletage* and the
padded gowns of fashionable women seen from the rear. But
at times he also treated the epic concerns of his oils in the water-
colour medium, as in *Oedipus cursing his son Polynices*, in which 52
he deploys the full power of the *terribilità* he imitated from
Michelangelo.

53 FRANCIS TOWNE, *Inside the Colosseum*, 1780

54 WILLIAM BLAKE, *The Simoniac Pope*, 1824–27

31, 54 Fuseli said that Blake was 'damned good to steal from'; and William Blake is, of course, the climax of the late eighteenth-century ultras. By profession a reproductive engraver, he became acquainted through his employment with the form-worlds of medieval sculpture and of Michelangelo. What marks his especial significance in England is his combination of artistic with literary power. His modes of expression were the lyric and the epic as much as the engraved copperplate, the watercolour and the tempera painting. In his earlier painting the impulse comes from medieval history, and it is in such subjects as *The Repentance of Jane Shore* that his treatment has been confused with Edward Dayes'.

76

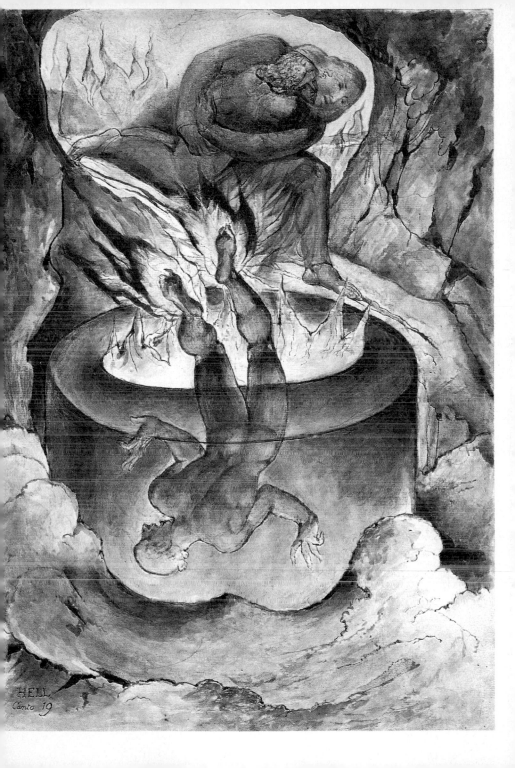

HELL
Canto 19

Blake was equally fascinated by the Gothic line of medieval tomb sculpture and the High Renaissance style of Michelangelo. It is this combination of opposed styles which helps to give his images their compelling originality. In his watercolours that

31 originality reaches its climax in the illustrations to Dante, which he embarked upon at the age of sixty-seven. The watercolours were intended as the basis of line engravings undertaken by Blake himself, but few of these were completed when he died. He had by then made a whole corpus of drawings, which go beyond his other work and summarize the content of his art. It need hardly be said that Blake's interpretation of Dante was not an entirely straightforward one; he regarded him, for instance, as an atheist. But the watercolours, by the natural instinct of genius, penetrated beyond any restrictive commentary, and achieved that most infrequent miracle, a marriage of text with

54 visual image. The horrors, such as the Simoniac Pope plunged upside down in boiling liquid, were naturally well within the late eighteenth-century idiom of Romanticism. What is more remarkable is the sympathy with which Blake imbues the pity and the terror of Paolo and Francesca's punishment, and the way he represents Dante overcome by horror but striding relentlessly through the muck of Hell. This he does with the lyrical freedom of his pencil line and the teeming fantasy with which he embodies Dante's descriptions in visible terms.

The capacity to carry drawing to the ultimate permissible limit of extravagance was not confined to the epic imagination of Fuseli and Blake. It was equally the basis of the British caricature, a mode of political expression as national as the watercolour, which acted as an outlet for the active social emotions of the late eighteenth and early nineteenth centuries, and provided entertainment as well as exercising some practical effect. The art of the caricaturist at this period also illuminates the relationship between the pure watercolour and the etching coloured by hand. James Gillray, incomparably the most savage and resourceful of the satirists, did few coloured drawings. Most of them are straightforward portraits, almost

miniatures, of the characters whose features he deformed in his cartoons. A gem such as *Cymon and Iphigenia*, showing a countryman enraptured by a bucolic Venus, is rare in his work. But he published prints which consisted of an outline etched by his own hand and washed with watercolours in accordance with his instructions. The resemblance with that type of water-colour in which a pen outline is filled in with flat colour washes is as close as between the drawings of Desprez and the coloured etchings which so resemble them. 55

Thomas Rowlandson spread his production more evenly over both these media. Less full of savage indignation, his satires on human foibles and the manners of his time have a humorous edge to them. Part of his ambition was to emulate the 56–7

55
JAMES GILLRAY,
*Cymon and
Iphigenia*

56 THOMAS ROWLANDSON, *Vauxhall Gardens*

picturesque landscape painting of his contemporaries, but the bravura of his pen work and the weakness of his colour washes prevented his success in this enterprise. When he is dealing with humanity his amused observation, akin to the comedy of Smollett and Fielding, and the animation of his line, creates a view of the late eighteenth century which is comical, kindly and wide ranging. He is as much at home describing fashionable life in the Mall as drunken orgies in a gambling hell; politics and hunting come with equal ease to him. This wide range of subject-matter leads on to the expansion of comic illustration of the nineteenth century. Dickensian in scope and in approach, it foreshadows George Cruikshank, and in a watered-down form, appears in Leech's cartoons for the early numbers of *Punch*.

57 THOMAS ROWLANDSON, *The 'Exhibition Stare-case'*

58 JOSHUA CRISTALL, *A Girl seated by a Well*

British watercolour in the nineteenth century

In his early days J. M. W. Turner mastered most of the styles of eighteenth-century watercolour; he went on in the nineteenth century to force the medium almost to the limits of its expressive possibilities. In the first phase of his career, which lasted till he was twenty-one, he confined himself to watercolour and drawing. The earliest public landmark was a watercolour of the Archbishop's Palace, Lambeth, which was accepted by the Royal Academy in 1790 when he was only fifteen. This was a talented exercise in the logical layout he had learned from one of his first masters, Thomas Malton, the teacher of perspective. Its type of formalism was soon softened by an increasingly Romantic attitude toward the choice of subjects and the method of treatment he bestowed on them. Already, by the time he showed *Tintern Abbey* at the Academy in 1794 he revealed himself as fully a master of the picturesque approach to ruins. At about this time he joined a number of young artists who met regularly at Dr Monro's house to copy drawings. This informal group, subsequently known as the 'Monro School' or 'Monro Academy', received supper and a small fee for three or four hours' copying. Its importance in the history of English watercolour is twofold. The copies the young artists studied included, besides works by Hearne and Dayes, many drawings by J. R. Cozens; and it brought together Turner and Girtin, who were to dominate the watercolour painting of the last few years of the eighteenth century.

From the start of his career Turner was aware of his genius and had no intention of placing trammels on it. One marked piece of evidence for this lies in his determination not to be solely a painter in watercolour. After the success he achieved so early the temptation to be limited in this way must have been a

strong one. Sandby, Cozens, and, among his contemporaries and successors, Girtin, Varley and de Wint concentrated on watercolour nearly to the exclusion of oils. But Turner, who painted his first serious oil with remarkable assurance at the age of twenty in 1796, had no intention of specializing in the same way. He felt that the highest reaches of the art were only accessible to the oil painter and pursued his most profound ambition, that of being an epic, historical landscape painter in that medium. But throughout his career he continued to paint *59–61* with prolific energy in watercolour.

59 J. M. W. TURNER, *The Funeral of Sir Thomas Lawrence at St Paul's*, 1830

84

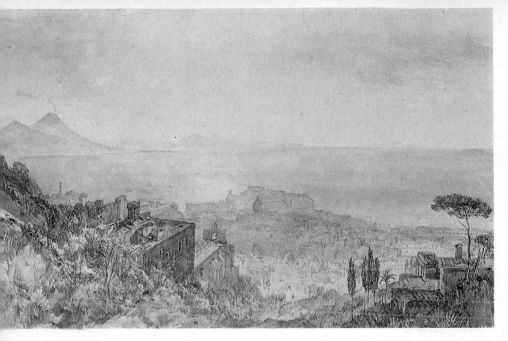

60 J. M. W. TURNER, *Naples*, 1819

The relationship between his watercolours and oils can be misunderstood. Sir George Beaumont, an arbiter of taste who became an inveterate opponent of Turner, said that his oils were enlarged watercolours, and Constable echoed this opinion. But in the main there is an absolute distinction between the method and intention he adopts in the two media. On the other hand he did make discoveries in one medium and translated them into the other. His first oil, *Fishermen at Sea*, shows him able to express greater varieties of nuance in light through this unfamiliar means than those he had been able to express so far in watercolour. But in the following year, in *The Transept of Ewenny Priory*, 1797, he exhibited a watercolour which a contemporary critic thought 'equal to the best pictures of Rembrandt', an estimate of its expressive power in light and shade which is hardly exaggerated.

85

It is noteworthy that although in principle Constable disapproved of recourse to watercolour by a landscape painter in oils, he himself made one or two notably individual contributions to nineteenth-century watercolour painting. The first was when on a visit to the Lake District in 1806 he painted a number of mountain scenes in a manner derived from Girtin; the second was when in the 1830s he adopted the practice of sending watercolours as exhibits to the Academy. His *Old Sarum* is a complicated, spectacular instance of this later phase of his art.

Turner laid the foundations of the fortune which made him independent of the tyranny of taste through the early sales of his watercolours. By 1799 he had more commissions in this field than he could execute. But once he had felt confidence in his power to handle oil paint he reserved this medium for the more ambitious pictures he showed in public, from *The Fifth Plague of Egypt* of 1800 to the *Angel standing in the Sun* of 1846. He was always ready to use watercolour for saleable works and commissions, and it remained the basis for the engraved topography which formed a large part of his later production.

Even with these limitations there is an extraordinary variety about the pieces he drew for specific purposes, and a constant progression in their style. He proceeds from the blue-grey pigments and the meticulously detailed drawing favoured by Dayes to a broader manner expressive of space. The development toward a full range of bright clear colour mainly occurred after he went to Italy in 1819, though there are clear signs of a livelier range of pigments before this happens.

Turner made use of watercolour extensively throughout his whole career for two widely differing purposes. The obvious purpose, the one which had governed the start of his career, was the public one of producing drawings for exhibition and sale. One of his chief patrons for such drawings till the 1820s was Walter Fawkes of Farnley Hall, who became one of his closest friends, first buying from Turner in 1803. When Fawkes put his collection of watercolours by modern British artists on public display in 1821 there were over sixty works by Turner among

thcm, comprising about two-thirds of the total. Their subjects ranged from the luminous and romantic drawings which he made after his visit to Switzerland in 1802 to the broad, sweeping views of the Yorkshire moors which he based on sketches from his many visits to Farnley Hall. Later, a good number of his finished watercolours were made for engraving; in these he developed his practice of fine brush strokes and minutely divided lights, possibly because this was best adapted to the linear work and cross-hatching which he wished to perfect in the steel engraver's craft.

He was always experimenting with technical devices; as early as 1799 Farington recalled that he drove 'the colours about till he has expressed the idea in his mind'. The exploitations of happy accidents – blots, thumbprints – remained with him; and until the very end of his career Turner found no difficulty in selling his watercolours at a time when his more advanced oil paintings were being assailed with critical obloquy. But while he obstinately went on exhibiting his remarkable oil epics, such as the two paintings on Goethe's theory of colour *Light and Colour (Goethe's theory)* and *Shade and Darkness*, shown in 1843, he did not show to the public the watercolours in which to modern eyes he took his principles of colour to the furthest extreme. Finberg, the first person to make a systematic catalogue of the twenty thousand drawings bequeathed by Turner to the nation, and now in the British Museum, called these advanced sketches 'colour beginnings', and the name will stand as well as any other. In certain cases it is clear that Turner has taken one of these sheets of paper stained with brilliantly, seemingly haphazard pigment, and adapted it with his creative skill into a sunset scene, a seascape or a topographical scene. Others he left alone, as he may have felt in them that sort of completeness, abstracted from representation, which is now recognized as an expressive form of art. In his later sketch-books Turner used the same abandoned brushwork and liquid washes to create mysterious suggestions, full of atmosphere and light, of the scene before him.

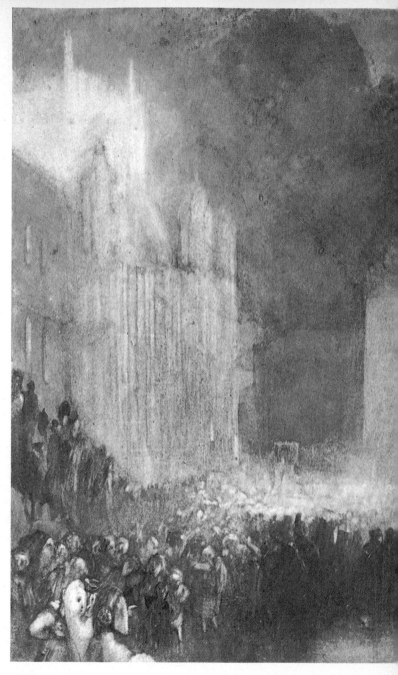

88

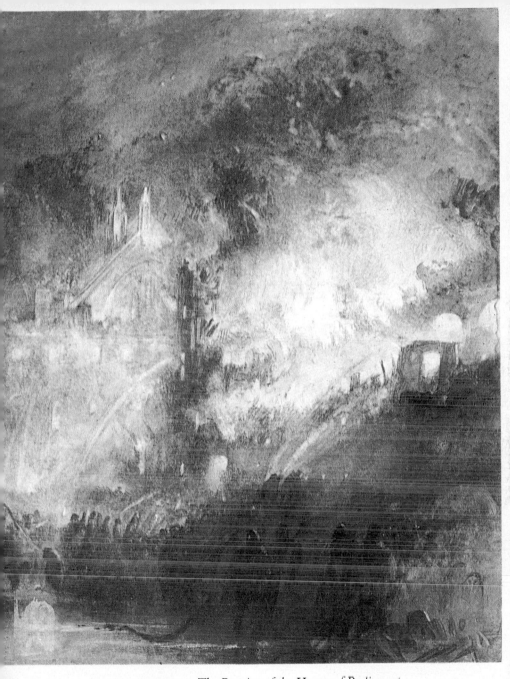

61 J.M.W. TURNER, *The Burning of the Houses of Parliament*

Thomas Girtin was born in the same year as Turner and was also a Londoner by origin. Before the two young artists met at Dr Monro's evening sketching parties, at the age of nineteen or twenty, their formative periods had been distinct. Girtin
began as an apprentice to Edward Dayes; the grounding he received from him in the high eighteenth-century manner he put to good effect in improving the drawings of the antiquary James Moore, with whom he travelled in Scotland and Wales. Even as late as 1797 a critic commented on the extent to which Girtin's style was based on Turner's; but from then till the end of his short life in 1802 Girtin developed a precocious and individual style which makes him one of the most original of the English watercolourists. He took a number of hints from his predecessors; by copying architectural subjects by Marco Ricci and Piranesi he acquired his skill in rendering the crumbling surfaces of ruined buildings. From the paintings and drawings of Canaletto he fed his instinct for the wide spaces of moorland and dale, and also the rhythmic drawing of his

62 THOMAS GIRTIN, *Kirkstall Abbey*

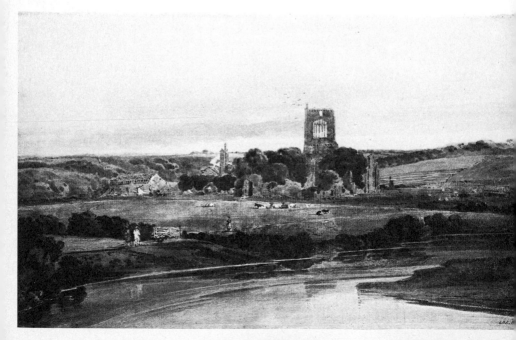

63 THOMAS GIRTIN, *View on the Wharf, Farnley, c. 1800*

figures. Above all, he learned from the drawings of John
Robert Cozens which were used as copies in Dr Monro's *44–6*
evening gatherings. His work parallels them in the drama of the
skies, in the spaciousness and elimination of inessentials and in
the reflection of local colour for a monochromatic tonality. But
while Cozens' range of blues and blue greys expresses his
melancholic temperament, Girtin's more optimistic frame of
mind is revealed in the warmer browns and ochres.

Although Piranesi was one of the artists he copied, Girtin
hardly took over from him that drama of the interior, dimly lit
halls and fantastic architecture which were of predominant
interest to other late eighteenth-century artists. The two themes
of his mature years, the last four or five years of his life, were the
broad spaces of dales and valleys closed by mountains and
the metropolitan landscapes of great streets. Of the former,
the *Kirkstall Abbey* in the Victoria and Albert Museum is a *62*

sufficiently famous example, revealing alike his mastery of perspective and tone, and that correspondence between sky and earth which was probably one of the aspects in his drawings most congenial to John Constable. The town views were encouraged by his making a panorama of London. This was a type of spectacle which became popular in England at the end of the eighteenth century: a kind of illusion which surrounded the spectator with a full-scale representation of a specific scene. The finished product was akin to theatrical scene painting; detailed sketches entered into its production. In this way Girtin drew a virtually complete circle of views from a high point on the South Bank of the Thames; it was exhibited under the name Eidometropolis in 1802. Before this, in 1801, he had gone to Paris. It seems that he wanted to arrange to show his London panorama there; perhaps also he intended to make a similar spectacle of the Parisian scene. Whatever his motives, he did complete before his death a number of masterly drawings of the city's streets, in which many perspectives of similar buildings are treated with an ability which gives variety to uniformity, and was to be emulated by a whole school of picturesque topographers beginning with Bonington.

In making a panorama, and in arranging for a set of aquatints of his Paris scenes to be published, Girtin showed that he was alive to the most up-to-date uses of his medium. In another of his interests he broke fresh ground. He was an originating member of a sketching society founded in 1799, and this society took as its aim, 'establishing by practice a school of Historic Landscape, the subjects being designs from poetick passages'. To do this the members selected some lines from an established or popular author, and developed compositions from their own imaginations during an evening session of three or four hours. The club of which Girtin was an early member survived, with many changes of membership, for over forty years. Among the authors drawn on for quotations were Shakespeare, Dante, Ovid, Virgil, Milton and Ossian. Many of the products of these sketching sessions are preserved in the

64 RICHARD PARKES BONINGTON, *Castelbarco Tomb*, 1827

65 JOHN SELL COTMAN, *The Ploughed Field, c.* 1807

Victoria and Albert Museum, and it is interesting to find that, although there is considerable variety in the designs evoked by the same theme the method of handling is so uniform that it is often difficult to assign the drawings to specific artists when there is no reliable tradition as a guide. The type of subject most popular was a passage creating a generalized poetical image, rather than, as in classic historic painting, a reference to specific episodes in the life of heroes, or famous men or Biblical characters.

At a meeting of the Sketching Society held early in the nineteenth century the subject proposed was 'Towered Cities please us then', from Milton's *L'Allegro*. The artists present on this occasion included John Sell Cotman, a young man who had come from Norwich to make his mark in London. Among the drawings for this evening his are distinguished by their remark-

65-7

94

66 JOHN SELL COTMAN, *The Dismasted Brig*

able control of flat washes, and the tautness of their total effect. Cotman had been one of Dr Monro's copyists a few years after Girtin, and seems to have received his first impetus towards breadth of treatment from his example. But he always had an instinct for colour, and his best work is not in the imaginative monochromes made for the Sketching Club, but the vibrant watercolours he made of the Yorkshire dales. The climax in his career came early. He visited Yorkshire in three successive years, 1803, 1804 and 1805; that is, when he was from twenty-one to twenty-three years old. While there he was hospitably received by the Cholmeleys of Brandsby, and in 1805 he stayed also with the Morritts at Rokeby Park, famous as the home of the 'Rokeby' Venus. This house was on the River Greta, and it was of this scenery that he made his most effective and individual drawings, such watercolours as *Greta Bridge* and *The Drop Gate*

95

67 JOHN SELL COTMAN, *Chirk Aqueduct*

in Duncombe Park. In these magnificently accomplished works the large masses and the minor details are disposed in as rigid a geometry as that found in Poussin's landscapes. But the adaptation of the watercolour medium to the artist's vision is complete. Analysed in one way the drawings are a combination of one dimensional patterns, arranged in the fashion of an abstract painting, and suggesting recession by devices similar to the flats in a stage setting. At the same time they are serene views of rocky streams and leafy parkland communicating the sense of a moment of vision captured for all time. Their unique authority is due to Cotman's holding in balance a number of precarious elements; the control of his flat areas of wash, the harmony of colour, his refusal to swamp expression by too much detail, his sense of the structure of the scene.

That such a happy equilibrium could not be always maintained throughout his subsequent career of over thirty-five years was partly due to the imbalance in Cotman's own mental make-up. His early good luck in attracting Dr Monro's attention was not matched by an equal fortune in patronage. Because his Yorkshire drawings did not sell well he returned from London to Norwich. In 1807, when he took this step, there was some reason for him to believe that the Norwich School of artists was going to become a vigorous and successful local group. Crome's reputation – he himself made few watercolours, but they are among his most solid constructions – was rising, and the local Society had just held a public exhibition. But there were too few buyers in this local market, and Cotman became drawing master to the daughters of large houses and in particular the pensioner of Dawson Turner of Yarmouth. He needed the reassurance of this security. Dawson Turner, an enlightened amateur, was an archaeological enthusiast, and Cotman entered willingly into his plans for producing illustrated volumes on Norfolk churches, their brasses, and on the scenery of Normandy. At times his drawing at this level is little more than hack-work. At other times he felt the impact of the most vigorous colouring of his younger contemporaries. 'My

97

poor *Reds, Blues* and *Yellows* – for which I have, in Norwich, been so much abused and broken-hearted about are *faded Fades* to what I saw' (of J. F. Lewis's work in 1834). But at infrequent intervals throughout his later life he was able to recapture the insight combined with technical strength of his early Yorkshire period; as, for instance, in the *Dismasted Brig*, which embodies the melancholy which was his recurring mood.

66

Cotman returned to London for the last eight years of his life, to work as drawing master at King's College. The chief development in his art arose out of his experiments towards a medium which was to combine the advantages of watercolour and oil painting. This he found in a kind of paste which enabled him to express a recollection of earlier motifs with a new linear rhythm; it has a semi-opaque quality and remains moist long enough for him to work subtle accents into it.

The first decade of the nineteenth century saw the emergence of many of the classics of the English School of watercolourists – Cotman, Varley, Cox, de Wint, Prout. It also witnessed the foundation of the first of those societies specially dedicated to watercolour which had so struck Edmond About in the discussion of the 1855 Paris Exposition. This organization, later known as the 'Old' Watercolour Society, was founded in 1804 to meet a specific need which its organizers had quite correctly identified. The Royal Academy, by then over thirty years old, admitted watercolours to its exhibitions, but hung them disadvantageously amidst oil paintings and miniatures, and did not select the pure watercolour painters who were not also oil painters into membership. Accordingly a number of artists who felt unfairly treated by this arrangement grouped themselves together to form an exhibiting society to be for watercolours only.

They held their first exhibition in 1805. The success was immediate, and attendances and sales were so good that a rival society, the 'New Society of Painters in Miniature and Watercolours' was founded in 1807; another factor was the fact that the first Society was an exclusive one.

68

98

68 GEORGE SCHARF, *The Interior of the Gallery of the New Society of Painters in Watercolour*

The stars of the early days of the 'Old' Watercolour Society were John Varley, Joshua Cristall, George Barret and John Glover. In their individual ways these men represent a certain fossilization of the British landscape tradition. They use the medium with great skill, they apply it in the main to landscape, and they see that landscape through the eyes of the Old Masters, more particularly the seventeenth-century landscape painters such as Gaspard Dughet. The most original is Cristall. He is a representative in watercolour of the neo-classic movement which was reaching its climax in England in the architecture of

70–1, 58, 69

58

Robert Adam and the sculpture of Flaxman. He had, more than most watercolour painters of his time, a penchant for figure composition, and he casts them into the cold sharp light characteristic of neo-classic painting, shaping them with reference to Greek models. He was fifteen years older than Cotman, and his broad washes – his wife used to criticize his work as unfinished – may well have influenced the younger man.

John Glover's main distinction consists in inventing a method of splitting his brush into many points so that he could paint foliage and water in detail without fatigue. He, and the other founders of the Society represented all the artificiality of vision against which Constable was rebelling in the interests of a natural style of painting, and it was with trenchant irony that he echoed the popular descriptions of Glover as the 'English

69 GEORGE BARRET, *Windsor Castle*

70 JOHN VARLEY, *Waltham Abbey*

71 JOHN VARLEY, *Snowdon* (unfinished)

Claude'. Glover was more adventurous in his life than in his art, and at the age of sixty-three uprooted his family for Tasmania, where he added by his farming to the fortune he had made by his art. George Barret, a man of melancholic temperament, had a more genuine affinity with Claude. Where Glover's drawing is niggling, his is more direct and assured, and he had a feeling for twilight which gives poetry to his compositions, artificial though they may be.

John Varley gave much of the character to the exhibitions of the 'Old' Watercolour Society by the sheer quantity of his contributions. The system he derived from the study of other people's painting is most succinctly summed up in his own phrase 'Nature wants cooking.' His original work is repetitive and frequently uninspired, but always ably put together, a quality we should expect in one who was an excellent teacher, in great demand. He was a true exponent of the picturesque, advocating recourse to contrasts of colour, shape, texture and movement, and putting his influence on the side of breadth rather than deliberate detail.

It was the intake of new members into the Society around the years 1810–12 which revitalized it, and extricated British watercolour painting from the brownish Claudian rut into which it was falling. The most able of the rising artists became the leaders of the second generation in the Society; they included David Cox, Peter de Wint and A.V. Copley Fielding. Both Cox and Copley Fielding were pupils of John Varley, and Cox most thoroughly outstripped his master in artistic development. Before his more strictly professional training he had been a scene painter, working under Macready's management in his native Birmingham and then at Astley's circus on first coming to London about 1805. His earlier manner is an application of the formally picturesque style; he both copied and imitated Gaspard Poussin. The technical treatises he wrote in the second and third quarters of the century were influential and embody a more positive approach to the use of direct colour. Like most watercolour artists of those times, Cox was affected by the

102

72 DAVID COX, *Pont des Arts, Paris*

73 DAVID COX, *The Challenge*

sudden richness which fell on Turner's palette after his first visit to Italy in 1819. It is his later manner which is most original and of greatest interest today. He was responsive to the trend (noticeable in oil painting in the works of the Barbizon School) whereby sketches could now be exhibited as finished pictures. He studied Constable – there is a watercolour copy by him of the mezzotint by David Lucas of *Spring: East Bergholt Common* – and he shared with him a fondness for the ever-changing appearances of the sky and earth. His subjects are drawn from the normally accessible areas for picturesque sketching: North Wales, medieval buildings, France, the sea coast. Through these scenes the wind is usually blowing, and by a deft use of direct painting with large brush strokes of bright colour he conveys the feeling that the foliage, the sea and the sky are in motion. In a backward look his art has been called 'Impressionist' with more justice than usual, for there may be a direct link between his watercolours and those of Eugène Isabey; and Isabey in his turn influenced the development of Boudin.

74 JOHN CONSTABLE, *Old Sarum, Wiltshire,* 1834

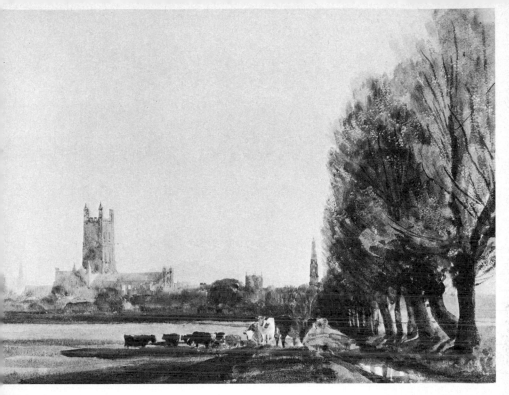

75 PETER DE WINT, *Gloucester*, 1840

Most landscape painters at this time were prepared to take the
generally accepted picturesque sights in their stride; Cox's
visits to North Wales were following the tradition of Gilpin
and Sandby. But there were others whose sensibilities were most
alert in a limited countryside with which they felt a special
affinity. Constable's addiction to the Suffolk landscape is well
known. The flat, uneventful landscape of Lincolnshire,
Tennyson's 'level waste, the rounding gray', might seem an
unpromising area for such affection. Yet it was a favourite
subject for Peter de Wint, and he was led to it by its personal 75–6
associations. As a student he had become a friend of William
Hilton, a talented and underrated historical painter, and he

married Hilton's sister in 1810. The Hiltons' home-town was Lincoln, and the town itself, the countryside and the similarly uneventful agricultural lands of the Midlands, became the favourite subject of de Wint's art. Possibly as a legacy from his Dutch ancestry he had a natural feeling for wide panoramas of landscape, and this was reinforced by the study of the Girtin watercolours in Dr Monro's collection. His personal style is dominated by his fondness for rich tones of colour. In some respects he was an oil painter *manqué*. He had no success with his oil paintings in his lifetime, but after his death a cache of them was discovered which includes some of the most important naturalistic English landscapes of the early nineteenth century. He likes to introduce into his paintings a factual representation of the country life around him – the haymaking, the slow progress of barges along the rivers. He had an immense vogue as a teacher, and there are many deceptive imitations of his distinctive style by these pupils.

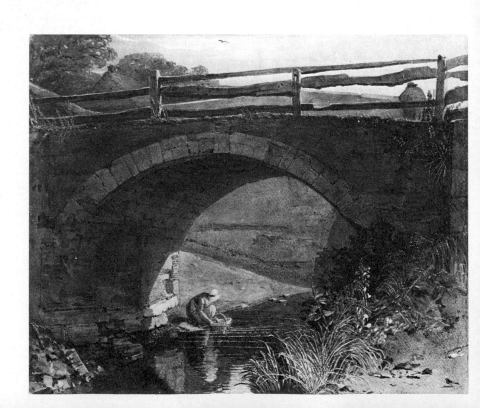

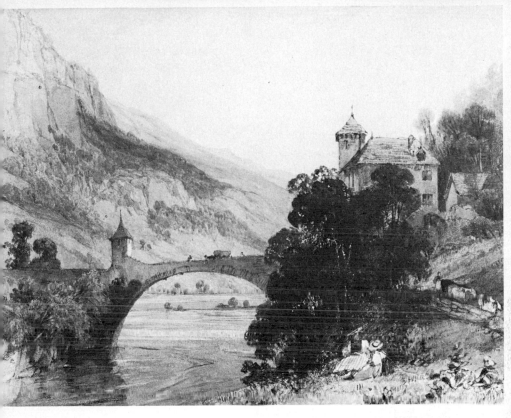

77 RICHARD PARKES BONINGTON, *Bridge of St Maurice, Valais, Switzerland*

By the 1820s the connoisseurs of picturesque art were beginning to want something fresher than the solid comforts of John Varley and Copley Fielding. They found it in the brief but meteoric career and the long continued influence of Richard Parkes Bonington. He is one of the rare artists to have bridged the gap between English and French painting. His father, an improvident and not over-scrupulous man, took him to France when he was in his teens. He learned from Louis Francia, another Anglo-French artist, and became the friend of Delacroix and the admiration of Romantic circles in Paris. From Francia he learned about the tradition of watercolour in the

64, 77–8

76 PETER DE WINT, *Bridge over a Branch of the Witham, Lincolnshire*

manner of Girtin and Varley. The prevailing French atmosphere, its Romanticism, its searching inquiries into the function of colour as opposed to drawing, and his own original talent rejuvenated the style of the early nineteenth century.

Bonington died at the age of twenty-six in 1828; knowledge of his work hardly began in England till two years before his death. He was as light in key and as effective in oil as in water-colour, but his natural bent towards the precise control of his washes, and his instinct for rich, gay transparent colour was indeed novel, and captivated French artists, to whom the medium was almost unknown. Both Baron Gros and Corot were immensely moved by a chance sight of one of his watercolours.

Bonington did not confine himself to landscape. He com-
78 posed many figure subjects of scenes from the sixteenth and seventeenth centuries. This aspect of his work runs parallel to similar developments by his friend Delacroix, and even in the work of Ingres, a characteristic expression of that type of Romanticism which seeks to re-create the historical or imagined past.

Bonington had a number of close followers and imitators:
98 among French artists, Roqueplan and Isabey; among the English, Thomas Shotter Boys, James Holland, William Callow and John Scarlett Davis. Their work is often so easily confused with the progenitor of their style, and so many falsifications were made immediately he died that it is easier to understand the significance of the 'Bonington style' in English and French art during the second quarter of the nineteenth century than to be certain about the authorship of many of its embodiments.

Another of the aspects of early nineteenth-century water-colour painting in Britain which gives it variety and provides a constant renewal of interest is the quite exceptional work done by the little band of Blake's followers. They copied the Sketching Societies, and anticipated the Pre-Raphaelites, in forming a Brotherhood. Variously known as the 'Ancients' or

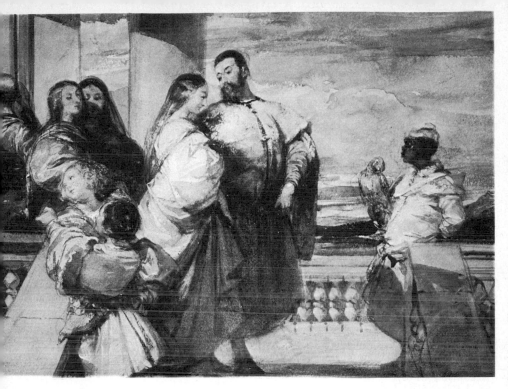

78 RICHARD PARKES BONINGTON, *A Venetian Scene*

the 'Extollagers' they met in the heart of the Kentish country side for the release of high spirits and the mystical contempla- tion of nature. This band consisted of John Linnell, Samuel *79* Palmer, George Richmond, Edward Calvert and Francis *80, 81* Oliver Finch. Each of these artists carried on, in individual ways, the poetic tradition in landscape, with its strong roots in the pastoral of Virgil and Milton. Finch, the most conventional of the group, cast his reflective compositions in the mould of Claude. Calvert made a precocious start, before he had en- *81* countered Blake's work, in his *Primitive City*. The backward- looking idyllic quality of this miniature watercolour was reflected in a number of woodcuts which express a remarkable exotic paganism. Linnell's few watercolours – he mainly

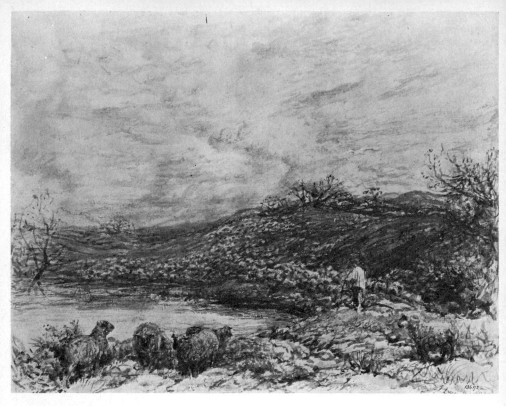

79 JOHN LINNELL, *Collecting the Flock*, 1862

practised in oil – exude his feeling for the highlights of country life, sheep-rearing and harvesting – with a nice sense of texture and line.

But the most outstanding of the young rebels who regarded *80, 88* Blake as a prophet was Samuel Palmer. The productions of his most original and creative period, which extended from 1827 till about 1835, are rightly described – as he himself described them – as 'visions'. In them he expresses the scenes near Shoreham, the Kentish centre of the Extollagers, through an eye educated by medieval ideas and with emotions exalted by a sense of communion with nature. These led him to the introduction of new technical devices to express his ideas – the thick

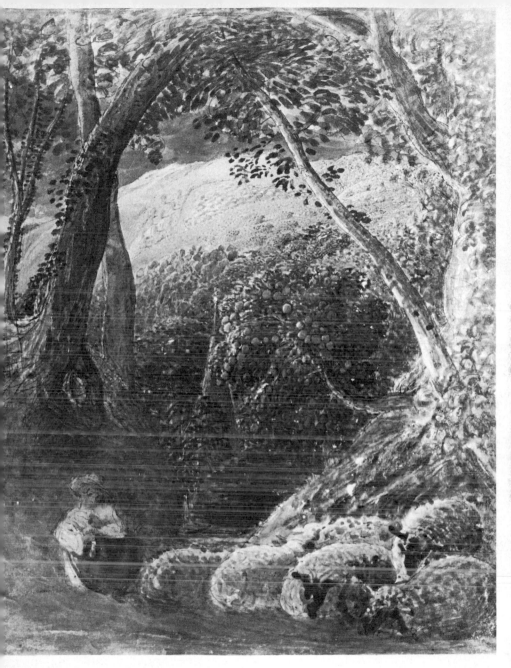

80 SAMUEL PALMER, *The Magic Apple Tree*, 1830

81 EDWARD CALVERT,
The Primitive City, 1822

bosses of opaque colour, the use of gold and a linear arabesque, especially in his foregrounds. The mood of a golden age of magic fruitfulness is embodied in such remarkably inventive drawings as *In a Shoreham Garden* and *The Magic Apple Tree*. But these were almost private utterances, works which Palmer did not sell and only allowed a few sympathetic friends to see.

88, 80

After marrying Linnell's daughter in 1837 he had to make a more determined effort to meet the taste of his time. He came to combine an appreciation of the picturesque beauties of Italy with a modification of his visionary style. There are still twisted barbed-wire foregrounds in a larger scale than the rest of his picture; but the overall impression was sufficiently in accord with current taste for Charles Dickens, no friend of revolutionary art, to choose him as the illustrator for his *Pictures from Italy*, published in 1846. His later work, though it displays flashes of his old power, is less distinctive.

Artists such as Cox, Bonington, Palmer took Continental subjects as a means of expressing their overall vision. A whole host of their contemporaries and successors were more strictly topographical artists. Joseph Nash satisfied the desire for paintings of Elizabethan halls with works, in which gouache figures largely, of surprising brilliance. Others travelled further for subjects; their views became widely known from engravings even more than from the exhibitions. Above all, they

112

encouraged the British middle classes to travel abroad, and provided mementoes of their visits after their return. Of these topographers, avid seekers-out of crumbling medieval ruins and quaint recesses of old towns, Samuel Prout was the most esteemed. His sketches suggested to Mrs Ruskin that her husband and her child might go with her to see these sights, and John Ruskin repaid the debt by praise of Prout which now seems extravagant. Others following a similar path were Henry Edridge, John Burgess, J. D. Harding, T. M. Richardson. The Bonington tradition was represented among them by James Holland, who worked extensively in Portugal as well as Venice, and William Callow who lived to the age of ninety-six and visited practically everywhere on the tourist's map. William James Muller, a brilliant executant, went as far as Turkey in his quest for exotic subjects. Wider travellers continued the work of the eighteenth-century draughtsmen in charting out territory unknown to the English: George Chinnery in India and China, Thomas and William Daniell in India, W. H. Bartlett in America and Canada. *82*

The most original of these artists was John Frederick Lewis. *91* Beginning in a vein similar to that of David Roberts, he travelled to Spain and found there an expansive sympathy for the Mediterranean life which is expressed in the lithographic series *Lewis's Sketch of Spain and Spanish Characters*, and in his watercolours of similar themes. His real breakthrough into originality occurred during a ten-year stay in Egypt. Here he sharpened his vision in the relentless light, and devised a method of painting in the finest detail which, though it is diametrically opposed to the breadth of Girtin, Cotman and Cox, creates its own surface and its own jewelled quality. The degree to which he carried the quest for finish is shown by his own remark that 'when he left off for the day, he had the satisfaction of knowing that he had finished a camel's eye'. The strain of this concentration was such that, after over thirty successful years specializing in watercolour, he decided to revert to oil painting, in which he could make more money for less hard work.

82 WILLIAM JAMES MÜLLER,
An Eastern Burial Ground

It was probably inevitable that, as he reappeared on the English scene in 1850 with a spectacular example of his new manner, *The Hhareem*, Lewis should have been regarded, particularly by Ruskin, as a Pre-Raphaelite. But he was not a close associate of that Brotherhood, and the superficial resemblances are the key to a deeper diversity of intention and approach. Millais once found himself being taken to task by Lewis for, of all things, the lack of finish and the excessive use of impasto he found in Pre-Raphaelite canvases.

The three Pre-Raphaelite painters – Rossetti, Millais, Holman Hunt – divorced themselves from current practice in water-colour as effectively as they had rebelled against current ideas for oil painting. Of the three originating members of the Brotherhood who used this medium, Millais was the least unconventional. He profited from his employment as an illustrator of social novels of the 1860s by making normal, clearly-viewed figure drawings of such subjects as *My First Sermon* and *My Second Sermon*. William Holman Hunt used

83 WILLIAM HOLMAN HUNT, *Athens*

watercolour more frequently after his visits to the East. He
stretches the expressive powers of the medium to the utmost by
subjection to his highly idiosyncratic sense of colour. Some of
his drawings appear discordant and garish to modern eyes.
Where he was wholly original, in a way not yet fully recognized,
was in his depiction of night scenes. Independently of Whistler
he responded to, and found a way of representing, the plummy
83 richness of the warm night sky, over Athens, from on board
ship or in Florence.

92 Watercolour came as the most effective medium of all to
Rossetti. He was always conscious of his natural defects in
handling oil paint, for which he had not received sufficient
technical training. When, after the success of his early oils
Ecce Ancilla Domini and *The Girlhood of Mary Virgin* he started
using watercolour, he said he found it a far faster means by

84 SIR EDWARD
BURNE-JONES,
Sidonia von Bork,
1860

85 JOHN WILLIAM INCHBOLD, *Vesuvius and the Bay of Naples*, 1857

which to meet his need for commissions. It is the medium in which he most effectively expressed his personal, poetic vision of the Middle Ages. The 'Golden dim dream', as Smetham called it, of the *Marriage of St George and the Princess Sabra*, and 92 *The Blue Closet*, for which William Morris, who commissioned it wrote a haunting poem containing the lines:

> *. . . they give us leave,*
> *Once every year on Christmas-Eve*
> *To sing in the Closet Blue one song*
> *And we should be so long, so long,*
> *If we dared, in singing . . .*

these convey the quintessence of Rossetti's disturbing and backward-looking vision.

86 GEORGE PRICE BOYCE, *Catterlen Hall, Cumberland*, 1884

The disregard of previous methods, abandonment of transparent, broad washes, the rubbing in of dry colour with extensive use of bodycolour and scratching out, reaches its peak in the work of Burne-Jones. He sometimes found it *84* necessary to warn his patrons that their purchases were not in oils, so confusing was his use of tempera and other devices. But this imitation of the appearance of a medieval manuscript, or the glow of stained glass, was an apt embodiment of the world of poetry and legend which he sought to re-create. The impress of Pre-Raphaelite vision is also seen in the watercolours of G. P. Boyce and John William Inchbold; but their technique *86, 85* was more in line with normal mid nineteenth-century methods.

From the second half of the nineteenth century till the end there was contention between the exponents of the broad

87 MYLES BIRKET FOSTER, *Children Running Downhill*

washes and suggestive brushwork of the classic masters of the
British watercolour, and the more recently exploited technique
of stippling and finely-wrought modelling. Among the former,
whose work has generally appealed to admirers of Girtin, Cox
and de Wint, are Thomas Collier, E. M. Wimperis, and James
Orrock. These are all landscape painters whose subjects com-
prised windswept heaths and cloudy skies. The other group was
far larger in number, and more to the taste of its own age.
91 John Frederick Lewis, who brought the stippled style to a
minuteness never exceeded, has already been mentioned above.
89 William Henry Hunt in the course of a long career devoted to
varying subjects in watercolour came to adopt the method of
broken patches of colour in place of his earlier tinted drawing
manner. In line with a general trend amongst the early Vic-
torians to appreciate the humours of childhood – Mulready
and Webster are two of the chief exponents in oil – Hunt made
copious drawings of his model, a small boy, in various comic
situations. When he turned to still-life his patience and finesse

88 SAMUEL PALMER, *In a Shoreham Garden, c.* 1829

of eye and hand were put to more exquisite use. No fruit painter of the period was more adept at rendering the bloom on a plum or the texture of a peach, and his studies of hedgerows with eggs in mossy nests gained him the name of 'Bird's Nest' Hunt.

87 In the 1860s Birket Foster's idyllic scenes of country life gained an immense popularity. This artist admired both W. H. Hunt and J. F. Lewis, and his style derives from their stippling manner. He did not view the harsh facts of rural existence with the realism which Van Gogh so much admired in such contemporary 'graphic' artists as Herkomer, Holl and Fildes. But his softer vision belongs to the well-established pastoral tradition practised earlier in the century by Palmer, Linnell and Calvert, and has an undeniable nostalgic charm.

The nineteenth century is the period in which book illustration reached its peak in England. In the earlier years, when

89 WILLIAM HENRY HUNT, *Plums*

90 FREDERICK WALKER, *The Fishmonger's Shop*, 1872

illustrations were more usually etched, such artists as Cruik-
shank and H.K. Browne ('Phiz') followed the traditions of
Gillray and Rowlandson in caricature. By the 1860s, and partly
through Pre-Raphaelite influence, a less humorous, more
sedate style became prevalent, the acme of middle-class decorum.
It was in this later mode that a number of the most eminent late
nineteenth-century watercolourists were nurtured, among
them Frederick Walker and G.J. Pinwell. The bias of their 90
choice of subjects reflects the interest of the later nineteenth
century in social problems and the delineation of the lower
strata of the community. Walker, and still more Pinwell,
looked at the life of the poor with understanding and recorded
it without undue embellishment. In this way their work is
distinguished from the contemporary idylls of Birket Foster;
but their technique relied as his did on the use of bodycolour and
fine stippling.

91 JOHN FREDERICK LEWIS, *The Hhareem*, 1858

92 DANTE GABRIEL ROSSETTI, *The Blue Closet*, 1857

93 PHILIP WILSON STEER, *Haresfoot Park, near Berkhampstead, Hertfordshire,*
1915

Their work also represents the last moment at which com-
plete insularity was possible for the British painter. The New
English Art Club, originally called the 'Society of Anglo-
French Painters', was founded in 1886, and the age of innocence
was over. Rebellion against academic rules and the importance
of subject-matter in painting was centred round the conduct of
oils, but carried some watercolourists with it as well. Tradi-
tionalists such as Callow, George Haydock Dodgson and
94 Albert Goodwin were working at the same time as Whistler,
an allusive exponent of the Impressionism in which he had been
95 nurtured, H. B. Brabazon, an elderly amateur who owed the
modernity he was found to possess in 1891 at the age of seventy
93 to his devoted study of Turner, and Wilson Steer, who reverted
to a conception of the watercolour sketch which would not
have seemed alien to Girtin or Cotman.

126

95 HERCULES B. BRABAZON, *After Sunset: View from the Artist's Window in Morpeth Terrace*

96 GUSTAVE MOREAU, *Sappho, the Greek Poetess*

The nineteenth century in Europe and America

The opposition between neo-classicism and Romanticism developed with the progress of the nineteenth century in Europe. On the one side were the idealists who sought to restrain impulse by a return to the forms of Greece and Rome – David, Canova and Thorwaldsen among them; on the other were the less austere spirits who believed in letting instinct and emotion play their part in the choice and treatment of subject. The liberty of the subject, the liberty of nations, enthusiasm, revolution, were the aspirations which guided the Romantics.

In painting the opposition of ideas ended in favour of the new, Romantic trend. This meant that landscape – the changing appearances of nature – and genre painting – the individual, the idiosyncratic exploration of daily life – ultimately took precedence over vast religious apotheoses and frigid classical scenes. The conflict had its specific technical aspect. Just as in the seventeenth century the Poussinistes, addicts of form and the ancients, had battled with the Rubénistes, devotees of colour and fluid as opposed to static form, so, in the first half of the nineteenth century, the neo-classicists were opposed to the Romantics. The rivalry became personalized again in France in the opposed practices of Ingres and Delacroix. For the former, drawing, the linear, monochrome element, is the essence of art; for the latter, colour is the factor which lies behind painting's strong appeal to the emotions.

The advance of the Romantic view of life gave some impetus to the greater and more expressive use of watercolour throughout the world governed by the more modern ideas. Not only was colour, far more powerfully than sculptural form, the means by which emotion could be conveyed; the rapid sketch

was itself the vehicle of Romantic emotion, able to capture the immediate impact of the emotion caused by fleeting visual appearances or the passing fancies of the mind. And so we find an increasing use in Europe of watercolour as an expressive medium, not matching in quantity, or specialist dedication, the English product, but parallel to it in technique and the purposes of its use.

The antinomy drawn between Ingres the classicist and Delacroix the Romantic is fundamental to their mature style. But there was a short period in his time as a student in Rome when Ingres was tempted to join the opposing party. From this epoch there are some freshly-coloured studies of the costumes of ecclesiastical costumes which express his delight in papal ceremony, and are linked with his ambition to paint pictures of the Troubadour period embodying the legends of medieval France. These gay designs are a brief and isolated interlude in his career. At other times when Ingres uses watercolour it is with a severely limited palette, and as an adjunct to a firmly rendered pencil drawing. This is as much the case in his *Dream*

97 EUGÈNE DELACROIX, *Jeune Arabe dans son appartement*

98 EUGÈNE ISABEY, *Fishing Boats beating to Windward*, 1841

of Ossian, a Romantic enough theme of 1809, as in his *Rape of Europe*, an imitation of a Greek vase-painting of 1863. Each is a tinted drawing, the drawing being of the right, fully-realized kind with which we are familiar in his expressly monochrome sheets; and no more form part of the history of watercolour painting than coloured engravings do.

With Delacroix, the archetypal Romantic painter, the case is utterly different. He thought in colour and composed in colour. To him the watercolour sketch was a natural mode of expression. He was using the medium in his earliest days – for instance in his designs for Talma's dining room started in 1821 – and continued its use throughout his career. His enthusiasm for it was sustained by his close friendship with Bonington, and other British painters of his circle in Paris, such as Thales Fielding, and renewed by his visit to England in 1825. The use of watercolour was yet another way in which he could manifest his love of all things English, but this would have hardly sufficed had not the existing state of the art expressly adapted it

131

99 EUGÈNE DELACROIX, *A page from the Moroccan Sketchbook, Meknes*, 1832

for the swift rendering of the thoughts which naturally occurred to him in a chromatic guise. Delacroix's is a skilful, exciting method of direct drawing with his brush loaded with transparent pigment. Out of a rich harvest of designs produced throughout his life, two groups stand out with special distinctness in their embodiment of his personal style and his originality. The earlier is the set of vivid studies of people and scenes in North Africa, made in 1832. These exotic splendours were a constant source of enrichment in his later work, and formed the basis of his *Women of Algiers in their Apartment* and many later canvases. The other group comprises the studies made on the sea coast in the 1840s and 1850s, such as the *The Cliffs at Etretat* and his remarkable studies of the sun reflected in the sea.

While Delacroix remains an innovator, not a follower, other painters who were attracted to the English art were closer in their discipleship to Bonington. Roqueplan and Eugène Isabey exemplify this dependence in a marked form. Isabey's subjects 98
in watercolour were frequently taken from the Normandy coast which was a favourite with Bonington and his English followers. Gudin, a Romantic marine painter following in the steps of Géricault and Delacroix, frequently visited England and exhibited at the Royal Academy. In landscape another strand was supplied by the artists who were more impressed by Constable's contribution to the Salon in 1824. Of these men of the 1820s, Paul Huet was the most keenly influenced. His 101
watercolours derived a new looseness and became more responsive to atmosphere after his long delayed visit to England, which took place in 1862. Then he clearly studied Turner, and the result is evident in the lighter range of colours he used thereafter. Of the landscape and figure painters who emulated Delacroix in his journeys outside Europe, Alexandre Decamps is of 102
particular interest for his drawings and paintings in watercolour. With Horace Vernet, another Orientalist, Decamps was the favourite painter of the Marquess of Hertford, who bought many of his watercolours, a number of which are still in the Wallace Collection in London.

100 EUGÈNE LAMI, *Scene in Belgrave Square: Ladies entering their Carriage*

Natural landscape and the East were two preoccupations of the French Romantics; another was the study of everyday life, especially in its humbler aspects, where individual character is not overlaid by the customs of polite society. A whole group of contemporaries chose this theme – Eugène Lami, Henri Monnier, Paul Gavarni. Here again the influence of Bonington is far reaching. He taught Lami the use of watercolour, the medium in which he specialized. It was at his suggestion that Lami first visited London in 1829. Henri Monnier's stay there overlapped with Lami's. During this visit he came under the spell of Cruikshank's caricature, which was extensively admired by the Parisian Anglophiles. As well as employing watercolour these artists found the comparatively new medium of lithography an excellent means of multiplying and circulating their ideas. At this stage the lithograph entirely printed in colour had not been evolved, and the black outline washed with colour by

134

102 GABRIEL-ALEXANDRE DECAMPS, *Out of School*, 1841

101 PAUL HUET, *Le Pays de Lumières, near Crécy*

103 CONSTANTIN GUYS, *Inauguration of a Monument, Madrid*, 1840

hand gave a good approximation to a figure composition in pure watercolour. In his later career Lami concentrated on
100 scenes of fashionable life, and of Court functions. His devotion to his choice of medium is shown by his foundation of the Société d'Aquarellistes, which held its first exhibition in 1879. Doré, Isabey, Harpignies, Jacquemart and Tissot were among its early members, and by 1890 it attracted well over fifty exhibitors.

Paul Gavarni did not pay his almost obligatory visit to London till 1847. What fascinated him then was the life of the poor – the Dickensian visions of incredible squalor which the city afforded, and which were equally a subject for Doré's *London* in 1870.

The world of these artists – who could develop their talent without losing touch with the taste of their time – was explored
103 with even greater capacity by Constantin Guys and Honoré
104 Daumier. Guys was characterized once and for all when

136

Baudelaire named him the *Peintre de la Vie Moderne*. He repre-
sented modern life – latterly in its *demi-mondaine* aspects –
exclusively in drawing. Many of these works are in various
tones of warm monochrome, but he did frequently use water-
colour with dashing effect. Among Guy's earlier drawings are
those he made for the *Illustrated London News*, especially of the

104 HONORÉ DAUMIER, *Les (deux) Confrères*

Crimean War. Then in Paris he recorded the glitter of the Second Empire and the life of the *maisons closes*.

While Guys is its observer, Daumier is a trenchant commentator on the life of his times. He gave wide public expression to his radicalism and his criticism of bourgeois life, in the vast series of lithographs he published – over 3,500 in forty-two years. But his more personal ambition was for the creation of a monumental and, as he believed, a less ephemeral art out of his observation of daily life. In his watercolours he sought a balance between a fine, sensitive pen outline and dark-toned washes, giving a powerful effect of light and shade. With these means he returned frequently to one or other of a small group of subjects: Don Quixote, collectors examining prints, the third class railway carriage, the Law, the fairground.

105 JEAN-FRANÇOIS MILLET, *A Hilly Landscape with Trees and a Farmhouse on a Hill*

106 EUGÈNE BOUDIN, *A Summer's Day: Coast Scene*

While Millet, the most representative member of the Barbi-
zon School to use watercolour, was concerned in the main with
the harsh realities of peasant life and the landscape in which it
was lived, Boudin looked with a kindly eye at the rich elegance *106*
which populated the beaches of Deauville and Trouville at the
height of the season. His feeling for atmosphere, the fleeting
cloud formations, the changing sea, and the gaily coloured
groups of people make him a real man of the middle of the
century. He has profited by the immediate past, and the legacy
of English watercolour, and he looks forward to the Impres-
sionists whom he was one of the first to encourage.

The Société d'Aquarellistes did not encompass any of the re-
markable talents who were remaking the history of painting in
the second half of the nineteenth century. In a sense the Im-
pressionists may be said to have tried to make their oil paintings
aspire to emulate the appearance of watercolour in its bright,

139

transparent colour and its suggestive brushwork. Their attitude to drawing was an ambiguous one. While they were instinctively oil painters, expressing themselves most naturally with a brush loaded with oil paint on canvas, they all respected the hard line of academic teaching. Though they built on the foundations laid by the Romantics, they felt no undue attraction to English life or English painting; if they used watercolour it was as an extension of the style they had evolved in their mature work. Monet, Renoir, Sisley and Bazille all drew academic nudes at Gleyre's studio under the conditions described in George du Maurier's *Trilby*; Degas and Seurat venerated, and copied, Holbein's portrait drawings. Seurat, in drawing, never moved from the exploration of tone divorced from colour explicit in his remarkable conté crayon drawings. It was left to his follower, Signac, to interpret the doctrine of Pointillisme in watercolour; and his interpretation has a wavy, Baroque idiosyncrasy which foreshadows the linear rhythm of Art Nouveau. Monet was spurred on to higher things than caricature by Boudin, whose perception of tone was at its best in his watercolours and pastels. But Monet was in the main a direct painter, and drawing, still less watercolour, does not play an important part in his work.

Degas and Manet, when they wished to draw, rather than paint, in colour, turned more naturally to pastel than to watercolour, though Manet was capable of a firm and complete statement of what interested him, as his *Longchamps* demonstrates. His sister-in-law, Berthe Morisot, frequently showed watercolours in the Impressionist group exhibitions, and these works convey perfectly the subtle, intimate charm of her lovingly-observed, enclosed world. Camille Pissarro's lightly tinted pastoral scenes anticipate the colour woodcuts his son Lucien made for the Eragny Press. Of this remarkably gifted group of painters Cézanne was the one who was able to advance his art by the use of watercolour, and express in the medium ideas which he was groping, sometimes less effectually, to convey in his oil painting.

107, 122

140

107 PAUL CÉZANNE, *Still-life with Chair, Bottle and Apples, c.* 1905

Cézanne was bothered all his life by the question of outline. It was part of his greatness to be naïve enough to face the obvious paradox, ignored by the schools, that to draw a line round something is not to represent it in a painterly way. His dicta include: 'Drawing is merely the outline of what you see', and 'Draw; but it is the reflection which *envelops*; light, through the general reflection, is the envelope.' When he draws in pencil alone, he feels for the outlines of objects with four or five parallel lines. In the watercolour technique he developed late in life he was able to dispense with the practice and to resort to ever-increasing simplification. The salient accent in the landscape or still-life is rendered by a few dabs of unmodulated transparent

122

141

108 HENRI JOSEPH
HARPIGNIES, *Famars,
near Valenciennes,*
1886

colour, leaving the surface of the paper largely untouched, but
bearing its part in the total expression of the scene. Because they
are the end product of a process of elimination applied to a life-
time's experience, these watercolours have an unparalleled
authority and a sense of exactness in the placing of all their parts.

142

There are a few French artists who owe a great deal of their
reputation to watercolour but stand apart from the more active
movements of nineteenth-century painting; these include
Auguste Ravier, Henri Joseph Harpignies and Gustave Moreau. *108, 96*
Ravier was a recluse who had been fired by Corot's Roman

landscape; he also, in his search for naturalistic colour, put the example of Turner deliberately before himself. Among the few collectors of his work in his lifetime were some English people who bought his watercolours in Rome.

108 Harpignies was a slow starter, and went on working till his death at the age of ninety-seven. He was somewhat neglected in his own day. He painted much in oil, and the recognition of his special gift for watercolour was not generally made till the first years of the twentieth century. In his watercolours he applies the calm pastoral mood of Corot to the scenery of the Loire; and the breadth of his brushwork, no less than his freedom from any divagation into Impressionism, endeared him to the English critics of fifty years ago.

96 Gustave Moreau, equally remote from the academic mainstream and the avant-garde, was far from these gentle platitudes. His finely wrought miniature-like explorations of the themes of cruelty and vampirism attracted the prophets of the Decadence, chief among them being Huysmans, who gives in *A Rebours* a ▸ hypnotic description of Moreau's *Salome* and *The Apparition*: 'never before at any epoch had the art of watercolour succeeded in reaching such a brilliancy of tint; never had the poverty of chemical pigments been able thus to set down on paper over coruscating splendours of precious stones, such glowing hues as of painted windows illumined by the noonday sun, glories so amazing, so dazzling of rich garments and glowing flesh-tints.' He amplifies this criticism in *Certains: 'Une impression identique surgissait de ces scènes diverses, l'impression de l'onanisme spirituel, répété, dans une chair chaste.'* These criticisms crystallize the ambitions which the *fin de siècle* cherished for watercolour, both in its technique and in its spiritual tendency.

The art of Henri de Toulouse-Lautrec, who amplifies the subject-matter explored by Guys with a new realism, is fundamentally that of the coloured line. It pervades his paintings to the same degree as his lithographs. But he rarely used watercolour by itself. Anticipating the trend of the twentieth century towards a greater freedom in the use of material he sometimes

144

109 JOHANNES BOSBOOM, *Entrance to the Old Women's Home at Arnhem*

110 JOHAN BARTHOLD JONGKIND, *La Côte*, 1861

111 JOSEPH ISRAELS, *The Housewife*

uses tempera, oil and charcoal with watercolour, and a number of his most characteristic and expressive sketches in colour are executed by the means known to the French as *peinture à l'essence*. This consists of thinning down oil paint by the use of a large amount of turpentine; a fluid, partially transparent medium, it produces results which might easily be confused with gouache. This breaking down of the rigid distinctions between the results of one type of painting and another has more recently been carried yet further.

The Dutch School continued its way in the nineteenth century with a sturdy independence of other nations, though a few

expatriate painters were stimulated by their contacts with French art.

109 Johannes Bosboom is well known for his watercolours of church interiors, executed with a great feeling for depth and contrasts of light and shade. But as he came more and more under the spell of Rembrandt, he chose to draw in sepia lightly washed with colour.

110 J. B. Jongkind, though born in Holland, is more integrally a part of the French School. He settled in France, apart from short *98* interludes, in 1846, and Eugène Isabey was one of his teachers. His watercolours are, with those of Boudin, one of the chief intermediaries between the art of the first and the second half-century in France, and a powerful formative influence on Impressionism. These drawings are generally given form by a pencil outline, but retain their sense of light and their spontaneity of brushwork.

The three Maris brothers, Jacob, Matthijs and Willem, forsook the Romantic interpretation for a more direct reporting of events, and led the way towards social realism. In this manner they established the characteristics of the School of The Hague throughout the second half of the nineteenth century: its simple, airy, rather low-toned land- and seascape and its peasant *111* interiors. Joseph Israels gave to the latter subjects a greater sense of melancholy.

Breitner moved from The Hague to Amsterdam where he found a greater animation in the life of the city.

The influence of these artists, especially their social realism, entered into Van Gogh's early and most truly Dutch phase, the period when he made his studies of weavers. After he went to France in 1886 the gloomy tones in which he was painting were transformed into a glowing discovery of colour. In the four years of life left to him he painted few watercolours in his mature manner; his preference in drawing was for dramatic perspectives and the emphatic outlines of pen and brush. But in *112* a few works, such as *The Yellow House at Arles*, he has embodied the essence of the great oil paintings of this period.

148

112 VINCENT VAN GOGH, *The Yellow House at Arles*, 1888

The Belgian School had its Société d'Aquarellistes earlier than the French. It was founded in 1855, and there was sufficient interest in watercolour and its possibilities for a secessionist group, the Société des Hydrophiles, to be formed in 1883. Prominence was gained by J. B. Madou, the founder of the parent society, and by Guillaume Vogels, the self-taught inventor of a personal and summary notation. Flemish decadence has always revelled in full-blooded voluptuousness, from Rubens onward, and it was this aspect which appealed to Gustave Moreau. Of the *fin de siècle* artists, Félicien Rops is justly better known for his etchings and other graphic work, but

he made some watercolours of a light, lascivious suggestiveness. Fernand Khnopff carried the 'dandy' ideal of these decades to its extreme length by developing a technique in which watercolour, pastel, oil and other media were so intermingled that the spectator could not decide which was which. This was taking the practice of Burne-Jones, whom he venerated, to its logical conclusion.

Colour played little part in the German painting of the first half of the nineteenth century. Since they were spiritual followers of the medieval and the antique, outline and form were the basis of art for the Nazarenes and the German Romantics alike. In such an artistic climate watercolour could not play an important role in the development of drawing. Wilhelm von Kobell continued the eighteenth-century tradition in his hard, brilliantly-lit peasant scenes. Caspar David Friedrich, the great embodiment of the Romantic spirit in German landscape painting, earned the first recognition of his talents at the age of thirty-one when, in 1805, some of his gouaches were praised by Goethe. Shortly after this he began painting in oil, and it became rarer for him to express his haunted vision of the landscape, in which a solitary human being often turns his back on the painter, in the watercolour medium. Johann Anton Alban Ramboux, an associate of Overbeck and other Nazarenes in Rome, made of his *Moses and the Daughters of Jethro* a childlike, tinted drawing. Of the other early Nazarenes, Franz Horny stands out as having been almost exclusively a draughtsman and watercolourist; his landscapes are observed with the minuteness of observation which this group brought to all drawing, whether of figures or of their natural surroundings, and he washed his emphatic outline with indications of shade and colour. Among the next generation, Moritz von Schwind became an illustrator of fairy-stories and popular proverbs, with an engaging sense of humour.

113 Rudolph von Alt, like von Schwind a Viennese artist, displayed a far more advanced aptitude for watercolour in which the emphasis is not on outline and the modelling is expressed

150

113 RUDOLPH VON ALT, *Peasant's Room in Seebenstein*, 1853

with the brush and by variations of colour. This free approach, one more in common with the British School of half a century before, is found in some other German and Austrian artists who worked toward the middle and second half of the nineteenth century. Eduard Hildebrandt, another pupil of Eugène Isabey, *115* was commissioned by Frederick William IV of Prussia to fulfil the Romantic artist's dream of global travel. He recorded this voyage, which took him as far as South America, in three hundred watercolours which were designed to show the varieties of scenery he had sought out.

Adolf von Menzel was also a compulsive draughtsman, *114* who devoured the visual appearances of the Berlin world in

which he created his success as illustrator and painter. 'It is good to *draw* everything: to draw *everything* is better,' he said; and among his countless drawings are many watercolours painted with the most masterly directness. Early in his life he had admired Constable's sketches, which found their way to an exhibition in Berlin, and the same assurance in drawing the *coup d'œil* before him characterizes his work, which is pervaded by a dazzling and instinctive sense of style.

The British influence spread to Scandinavia, and Johan Christian Berger paid a number of visits to England. During the second, in 1836, he met Copley Fielding, who was the dominant factor in the development of his sea painting, best demonstrated in his watercolours.

114 ADOLF VON MENZEL, *In the Zoo*

115 EDUARD HILDEBRANDT, *Santa Cruz, Rio de Janeiro*, 1843(?)

Italy had been so strong a centre for foreign artists that its landscape painting at the end of the eighteenth century was frankly international. Out of this activity grew the 'School of Posillipo', of which the first leading master was the Dutch-born Anton Sminck Pitloo. He rarely worked in watercolour; but the second great artist of the school, Giacinto Gigante, who was born and died in Naples, became eminent through his water-colours.

116

It is now believed that one of the causes which resulted in the liberation of Gigante's style was the notorious exhibition of oils which Turner held in Rome in 1828. The first connoisseur to write about him, the British diplomat Lord Napier, said, during Gigante's lifetime, that: 'his favourite resort in summer is to the hills above Sorrento, just where cultivation mixes with the

116 GIACINTO
GIGANTE, *Pompeii*,
1862

pasture and the forest, where the grey rock invades the bloom-
ing terrace and fields, and the chestnut towers above the olive
and the vine. In this tempered region, where fertility and wild-
ness meet, on the boundaries in which Pomona debates with
Pan, where at every turn some feature, soft or savage, forms a

154

seductive . . . striking frame to the distant landscape, sig.
Gigante finds the subjects of those studies which for freedom of
handling, fidelity of colour, transparency, perspective and effect,
have no parallel in his own more ambitious canvasses or . . . of
any painter of his country.'

117 JOHN LA FARGE, *Military Dance at Samoa*

Watercolour had one of its most vigorous outcroppings in America. The closely observed bird-drawings of J.J. Audubon, so familiar from Robert Havell's engravings after them, were not at first matched by the records of the scenic beauty of this vast and immeasurably varied continent, though to set beside the Romanic canvases of Cole and Bierstadt there are some coloured sketches by Samuel Colman and Thomas Moran recording the spectacular appearance of Wyoming and Utah. The American Water Color Society, founded in 1866, had as its first president Samuel Colman, who also designed for Louis Tiffany. One of the founding members was Winslow *118, 120* Homer, who worked first as an illustrator for *Harper's Bazaar*, and also painted in oils, but whose great gifts were most fully expressed in his watercolours. Largely expressive of the isolated life he chose for himself in Maine or the Bahamas, his direct, full-blooded washes express the violence in the American temperament as well as his delight in the thing seen. His con- *117* temporary John La Farge was a more contemplative artist, and his decorative instincts were embodied in his numerous designs

118 WINSLOW HOMER, *Palm Tree, Nassau*

121 MAURICE BRAZIL PRENDERGAST, *Street Scene*, 1901

for stained glass. His capacity for the quick observation of the exotic was brought out by his visit to Samoa.

Thomas Eakins embodies the Yankee reverence for fact. He imbued his relatively scanty production of watercolour with the same calculated accuracy as his oil paintings. Reversing the usual process, he made studies in oil for such watercolours as *Negro Boy Dancing* and *John Biglen in a Single Scull*, and for the latter there is also a diagram working out the perspective to the last mathematical detail.

As the century neared its end, French influence was superimposed upon the factual reportage of the American artist. Childe Hassam brought an attractive version of Impressionism to the vision of his own country. Maurice Prendergast, who admired the work of Cézanne in Paris in the nineties, evolved an

119

121

119 THOMAS EAKINS, *Negro Boy Dancing*

120 WINSLOW HOMER, *Under the Coco Palm*, 1898

123 JAMES ABBOTT MCNEILL WHISTLER, *Grey and Green: A Shop in Brittany*, 1893

even more personal calligraphy in which decorative effect is balanced with his enjoyment of crowds and their background.

Homer, Hassam and Prendergast all returned home after their scholastic voyages to Europe; their lives invite a direct contrast with the more permanent expatriates. Edwin Austin Abbey settled in England, and turned his accomplishments as a kind of latter-day Pre-Raphaelite to the illustration of medieval legend. Mary Cassatt, Whistler and Sargent were less backward-looking. Mary Cassatt, the friend of Degas and Berthe Morisot, was a member of the Impressionist circle, and her American qualities were recognized behind the formal allegiance to the group's methods. Whistler, with a more complex division of *123* affiliations, was, like his French associates, more inclined to use pastel than watercolour, though he could occasionally do so with his exquisite eye for the nuances of atmospheric colour. But Sargent came to find more and more in his watercolours, chiefly made on his holiday expeditions in Venice and Spain, a relief from the demands of portraiture.

161

122 PAUL CÉZANNE, *Study of Trees*

124 LÉON BAKST, *The Blue Sultana in 'Scheherezade'*

The twentieth century

The developments which have taken place in the range of all the visual arts in the twentieth century are in the main a repudiation of principles which had hitherto been held to be self-evident. In fact, these rejected principles had only recently become fully established in Western European art, and even then only for the comparatively short period of five hundred years. There is a wide fluctuation of style in the art of these five centuries, ranging from International Gothic through the Renaissance, Baroque and Rococo to Naturalism and Realism; but underlying all these modes of vision ran the unquestioned belief that there were absolute limits to the divergence from a norm which could be tolerated. These limits were, briefly, that the picture should conform with the scientific rules of visual perspective and that figures and natural objects should conform to the appearances of normal sight in seeming to be three dimensional and remaining recognizable transcripts of their natural form. These tenets were eroded as questioning spirits created works of communicative power while flouting one or other of them. The painting and sculpture of the Post-Impressionists and the Fauves distorted the drawing and colour of natural appearances. With the Cubists, Futurists and Vorticists the emphasis was placed on the simple mathematical forms supposed to lie behind the facts of vision. In another direction, the desire to treat the paint surface as a decorative pattern led to abstraction, as well as some phases of Expressionist art.

It cannot be said that watercolour as such played a determining role in these trends, but these developments are all faithfully reflected in its own progress. And, since the art of any stretch of time is composed, partly of a continuation of earlier styles, partly of new fashions, there has been ample variety within

125 WYNDHAM LEWIS, *Sunset among Michelangelos, c. 1912–14*

127 PATRICK HERON, *Red, Olive, and Black in Plum*, 1961

126 WILLIAM SCOTT, *Composition in Blue*, 1969

128 CECIL A. HUNT, *The White Factory*, 1920

recent productions in this medium. The specialist societies exist
as they have done for a century and more, and produce work
which would have been acceptable to earlier committees and
which many people still find pleasing. What is most conspicuous
in a survey of watercolour since 1900 is that it is reverting to the
state in which we found it in the sixteenth and seventeenth cen-
turies. Many artists regard it as an auxiliary mode of expression,
to be used not as their predominant or exclusive medium but for
sketches and occasional complete statements. The boundaries of
definition have also been extended. The desire to confuse the
distinction between watercolour and oil, exceptional in Burne-
Jones and Moreau, has become commonplace. Collage, poster
paint, coloured inks and thin oil have all been used in a manner
which produces results like those of watercolour and gouache,

166

129 JAMES DICKSON INNES, *Waterfall*, 1911

130 JOHN MARIN, *The Singer Building*

131 CHARLES SIMS, *Bathing Party*

and the phrase 'works on paper' is now used to convey the idea formerly expressed by the familiar 'exhibition of watercolour paintings'.

The more traditionally-minded British watercolourists entered the new century with complete confidence. Their work covered a wide variety of styles, varying in landscape from the flamboyance of Brangwyn to the delicate Impressionism of Wilson Steer. Innes and Derwent Lees simplified their washes in *93, 129* the manner of Cotman. A more poetical element was to be discerned in the treatment of light by Cecil A. Hunt, and in the *128* ideal world evoked by Charles Sims in watercolour as well as oil. *131* Conder's paintings on silk and Dulac's illustrations are further excursions into a world of fantasy derived from the past.

132 SIR WILLIAM ORPEN, *The Model*, 1911

Figure painting was more prominent than before. It encompas-
sed the delicate nuances of McEvoy's portraits, the strength of
132 Orpen's tinted outlines, and the remarkable technical control
shown by Russell Flint in his nude studies. The artists connected
with the Camden Town group, Ginner, Gilman, Bevan and
Ratcliffe kept their watercolours close to the facts of the urban
life which they preferred to take as their subject-matter.

These were the artists whose main concern was the develop-
ment of the existing national tradition from within. But others
were beginning to reflect the results of Continental practice.

133 EDWARD BURRA,
Dancing Skeletons,
1934

134 FRANCES HODGKINS,
The Lake, c. 1930–35

136 Paul Nash evolved a personal style from a compromise between Cubism and the pastoral mood. It was an expressive instrument for interpreting the desolation in Flanders caused by the First World War, and the strain of poetry which runs throughout Nash's drawings was strengthened in the thirties by the use of Surrealistic imagery.

During the years 1913 to 1915 a group of artists developed an indigenous form of abstract art, based on the ideas of the Cubists and Futurists, but with a specifically British accent. These artists, who frequently worked in watercolour and *125* gouache, included Wyndham Lewis, William Roberts, David Bomberg, Laurence Atkinson and Edward Wadsworth.

135 GRAHAM SUTHERLAND, *Folded Hills*, 1945

136 PAUL NASH, *Eclipse of the Sunflower*, 1945

The atmosphere of hostility caused by these earlier steps towards a liberation from foregone conclusions can be sensed in some of the more conservative criticism of the twenties and thirties. Frank L. Emanuel wrote in 1927: 'In conclusion I feel absolutely certain that those of our landscapists of today who will do the fine work that will live are those carrying on the tradition of the healthy school of British painting typified by Callow, and not those who imitate the work of a group of foreign decadents, who were sodden with absinthe and diseased in mind and body.' A writer of an earlier generation, Henry Holiday, himself a good latter-day Pre-Raphaelite, wrote, after dismissing Cézanne, 'I have not mentioned the Futurists; brainless hooliganism does not call for criticism.'

173

137 HENRY MOORE, *Pink and Green Sleepers*, 1941

But this hostility gave an edge to dissent and acted as a spur to creation. The Omega Workshops organized by Roger Fry were a powerful force in promulgating decorative form in painting and, equally, the applied arts. Of the artists who were associated with the group, watercolour was used by Vanessa

139 Bell, Duncan Grant and Edward Wolfe. Wolfe in particular has allied a highly-keyed watercolour palette with strong powers of construction in many of his works. The climate of the thirties

135, 140 enabled Graham Sutherland and John Piper to infuse topographical drawing with a Romanticism allied to the followers of Blake, and in a language of forms derived from the Post-Impressionists. In those years the decorative gouaches of the

134 elderly New Zealander Frances Hodgkins received their greatest success, and a Celtic poetry was re-created by David Jones. The

174

138 ANTHONY GROSS, *Gateway into Germany: the Maas in Flood*, 1944

large, compelling watercolours of Edward Burra have a more *133*
biting edge to their fantasy.

The outbreak of the Second World War led to the establish-
ment of two official bodies which gave extensive work to water-
colour painters. In the expectation that much of the country
would be destroyed, and also to provide employment for
artists, the Pilgrim Trust commissioned a large series of draw-
ings and watercolours under the title *Recording Britain*. Among
those employed on the project were Kenneth Rowntree, John
Piper, Elliott Seabrooke, Claude Rogers, Ruskin Spear, Michael
Rothenstein and Walter Bayes. The War Artists Advisory
Committee employed a number of artists to provide an historical
record of the war. Among the watercolourists were Bawden,
who went to the Sudan and Iran, Sutherland, Piper, Eric

Ravilious, who was killed in action off Iceland, and Anthony Gross who travelled in the Middle East and India. Paul Nash recorded the war in the air, and life in the London Blitz caused Henry Moore to become fascinated with the sleeping forms in underground stations. These are the theme of his 'Shelter sketch-book', and foreshadow a host of other drawings in which he has worked out his sculptural ideas in a wholly individual use of watercolour.

138

137

These wartime records were necessarily representational and figurative, and by a natural process of reaction post-war painters reverted to symbolism and abstraction. In the beautifully poised gouaches of William Scott lingers a memory of the delicately

126

139 EDWARD WOLFE, *Assisi from Lady Berkeley's Garden*, *c.* 1960

140 JOHN PIPER, *The Coast of Brittany 1*, 1961

placed pots and pans of his more representational earlier work. Patrick Heron has turned from his admiration of Braque to the 127 glowing colour counterpoint of his pure abstractions. For these artists and many others, watercolour, gouache, or some similarly ductile medium used on paper appears as an alternative to the use of oils, not an exclusive method of painting.

Non-figurative painting has never been completely dominant in British art, because there has always run through it a lode of literary allusion, reflected in post-war watercolours by John Minton, Keith Vaughan and Ceri Richards. But its acceptance as the crest of the advancing wave was not seriously challenged till the late fifties, when the 'Pop' artists began to explore the use of popular imagery. As in 1910, in 1970 a variety of approaches to art are present at once and jostling for position.

141 ANDRÉ DUNOYER DE SEGONZAC, *La Route de Grimaud*, 1937

The French School began the twentieth century with the potential for changing the course of modern painting, but with no especial aptitude for doing so through watercolour. Picasso, Matisse and Braque had little recourse to this method of drawing in the formative years for Cubism, though they have used it occasionally; indeed collage, one of their main new methods, has an affinity with watercolour drawing in its effect. Of the most eminent painters of these years, only André Dunoyer de

141 Segonzac has produced a large body of work in watercolour in the way British nineteenth-century painters did. His linear sense is revealed in the great body of masterly etchings he has made, which convey his art as completely as his painting. His watercolours, mainly landscapes, are in essentials pen drawings washed with colour, and his range of colours is built round the

178

142 PAUL SIGNAC, *La Maison Jaune at Arles*, 1935

143 ANDRÉ DERAIN, *Bacchic Dance*, c. 1905–7

subdued earthy browns and grey-greens which became prominent in the Cubist period of Picasso and Braque.

142 Signac maintained the gay palette and light key of the Impressionists long after his work ceased to be in unison with their doctrines. There is a strong linear emphasis also in his style, though his outline, waving and baroque in its rhythms, is usually made in pencil. To this he juxtaposes blobs of pure transparent watercolour, a development of the divisionist style modified by his admiration for Jongkind. In the result his watercolours are, though decorative, more spontaneous in feeling than his oils. Henri Edmund Cross, a close follower of his circle, also used watercolour with a personal accent.

143 Among the Fauves, Derain occasionally drew in watercolour, especially in the period about 1905 when he was infusing a
146 world of exotic fantasy with corybantic energy. Rouault's

144 MARC CHAGALL, *The Green Donkey,* 1911

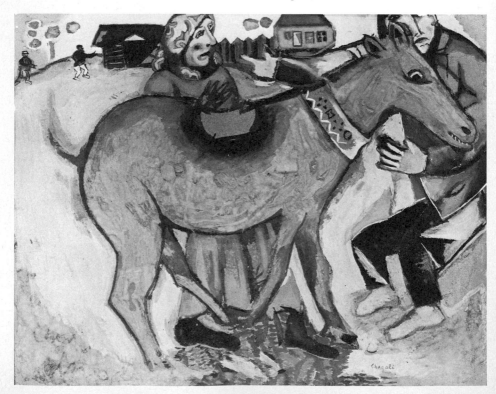

145 OSKAR KOKOSCHKA, *Polperro*, 1939

earliest independent work is found in the works on paper he made in the first decade of the twentieth century. He was the pupil of Gustave Moreau, and although there is nothing of the jewelled miniature about these early, fierce comments on society, he used a mixture of watercolour, gouache, pastel and ink which is all his own and leads directly to the stained glass tonality of his prints.

Dufy found in the covering powers of gouache a more sympathetic medium for his decoratively-linear coloured drawings. But it was not until the thirties that Bonnard made a serious attempt to use watercolour. When he did so he brought to it his gay informality of composition and remarkable tact in the management of light. Chagall also has made frequent and effective use of gouache. It is a medium in which he has found it _144_

fully possible to convey the fairyland world of Russian and Jewish imagery and legend which he brought to the West from his childhood in Viterbsk. And still in the years after the Second World War an artist who has made a reputation in the Ecole de Paris by other means may turn to gouache as an auxiliary mode of expression. Since Dubuffet, for example, has always had a fertile curiosity about techniques and has exhibited paintings made from 'botanical materials', it is no surprise to find that he also has used gouache.

Expressionism is a Northern mode of art, in which inward-looking and concentrated emotions are given vent in fierce distortion and disturbing colour. The great Norwegian progenitor *147* of the movement was Edvard Munch, and he was as adept at expressing his tortured vision in his coloured drawings, as in his woodcuts with their agitated line and keen sense of texture. Of the German Expressionists who created their work out of the

146 GEORGES
ROUAULT, *La
Fille au Miroir*,
1906

182

147 EDVARD MUNCH, *Landscape with Red House*

same emotional necessity, Emil Nolde was the artist who had 148 most affinity with Munch. Watercolour was a complete mode of communication for him, and it is possible to gain a comprehensive knowledge of his art from his drawings alone. In mood they range from the gaiety and Oriental simplicity of the sketches he made in the South Seas to the intense brooding scenes of the North German sea-coast. These have a rich complexity of colour which had hardly been seen since Turner's late work. And when he was forbidden to paint by the Nazis, an old man of seventy-four, he was confined to making, in secret, his *Ungemalte Bilder* – 'unpainted pictures'. Nolde has every technical device at his disposal, from placing a rich, loaded, wash on the paper, to letting it disintegrate into spots over a water-repellent surface. Indeed, he added a new device to the repertoire when he discovered that watercolour placed in

148 EMIL NOLDE, *Friesland Farm under Red Clouds, c.* 1930

freezing snow crystallizes: 'I also painted in the freezing evening hours and was glad to see the frozen colours turn into crystal stars and rays on the paper. I loved this collaboration with nature.'

150 Another isolated artist, Christian Rohlfs, evokes a delicate tapestry-like play of colour which surrounds his subjects, open flowers, with a luminous glow.

In the feverish early twentieth-century world of Austria, the world of Freud, Walden and Mahler, the painters' analysis of the human predicament centred on the figure. Gustav Klimt emphasizes throughout his drawings the decorative patterning *149* of fabrics, while Egon Schiele's distortions of line convey a *145* more savage criticism, and in comparison Oskar Kokoschka's watercolours of the twenties are almost classical in form.

184

It has frequently happened that travel to a more exotic land-
scape has refreshed an artist's vision. Delacroix's visit to Tunisia
was the occasion for his first systematic use of watercolour as a
sketching medium, and Nolde found transparent colour the
ideal vehicle for conveying the light effects he found in his
journey to the South Seas. Similarly, the journey which August
Macke and Paul Klee made to Tunis and Kairouan in 1914 had a *151–2*

149 EGON
SCHIELE,
*Nude with Mauve
Stockings,*
c. 1911

profound effect. Klee, who was then aged thirty-five, had concentrated on prints and drawings in black-and-white. After seeing North Africa he said 'Colour has taken hold of me; no longer do I have to chase after it. I know that it has hold of me for ever, that it is the significance of this blessed moment. Colour and I are one. I am a painter.' From then on he worked out this revelation very largely in watercolour, and indeed he is a painter who cannot be appreciated without his 'coloured sheets of paper'. In them he gives the fullest range to his whimsical fantasy, his interest in structure and his infectious humour. He was willing enough to sophisticate the transparent washes with glue, wax, paste and other mixtures, but his success with these variations of the base springs from the fact that a small sheet of paper provides the perfect scale for the re-creation of his personal miniature-like world. Macke, too, made on the Tunisian trip of 1914 a series of watercolours of remarkable directness and luminosity.

Other national schools were more local in their reach. In Belgium Rik Wouters exercised a natural talent for direct brush

150 CHRISTIAN ROHLFS, *Waterlilies*, c. 1936–38

drawing. Léon Spilliaert reveals a surrealist vision comparable
to that of Magritte and Delvaux in hard drawings, minute in
execution and sharply precise in their vision.

Apart from Leonid Pasternak, the father of the novelist,
whose drawings are a facet of the international world of the
nineties, the main Russian contribution to watercolour painting
has come from the brilliant group of designers whom Diaghilev
collected round him. Theirs is an interesting and triumphant
embodiment of the link which has existed for over four cen-
turies between stage design and coloured drawing; and they
have shown again how such designs can be self-sufficient works
of art in their own right. The demand for Bakst's costume and _124_
décor designs for ballet was soon so great that he was called
upon to duplicate them. Roerich was the perfect interpreter of
the barbaric splendour of *Prince Igor*; and Nathalie Gont-
charova and Mikhail Larionov brought to their designs a
modern awareness of the angular hieratic Russian icon.

152 PAUL KLEE, *Cacodemonic*, 1916

153 PAUL JENKINS, *Phenomena: Hellenic Lost*, 1962

154 CHARLES BURCHFIELD, *The False Front*

In the present century, painting in the United States of America has advanced from the modest imitation of European trends to a dominant position through its vitality and fertility of resource. Here, as in England, the art of traditional associations was for long not swept away by the forward-looking experimental manner of the avant-garde. Indeed, the more figurative painters in watercolour have been able to capture and record what is most individual and different about the American 155 scene. Edward Hopper, with a fine sense of structure and light, makes the ordinary suburban house or technological structure a 154 monumental thing. Charles Burchfield distils from the decaying cheesecake architecture of twilight urban areas the nostalgia it invokes in reality. William Glackens, in the manner of a deft illustrator, records the lovable vulgarity of Coney Island and

190

155 EDWARD HOPPER, *The Mansard Roof*, 1923

other places of resort. Andrew Wyeth renders the same type of setting with a greater instinct for loneliness, and of the artists who were caught up in the discovery of Parisian thought during the first decade of the century, Charles Demuth made a personal interpretation of the formulae of Cubism, varying at times his rather severe linear construction with more fluent and exuberant studies of flowers. Georgia O'Keeffe produces stark simplifica- *160* tion of the landscape of New Mexico which have the same strength as her formalized still-life.

John Marin visited Paris in 1905 and, from the age of thirty- *130, 157* five, painted watercolours in large numbers, impressions of New York or seascapes from the coast of Maine in which he simplifies and rearranges the data of the visible world even more radically. Both he and Milton Avery have the same control over the

156 SAM FRANCIS, *Painting*, 1952

157 JOHN MARIN, *Deer Isle, Maine*, 1927

flowing watercolour wash as Winslow Homer, but while Marin breaks up the image into facets in a way analogous to Cubism, Avery applies himself more immediately to *158* representation.

Lyonel Feininger, who was born in New York but spent many years in Europe, returned to America in 1936 and found in the skyscrapers of Manhattan the material for his personal refinement of Cubism and the doctrines of the Bauhaus. The mystical introspective strain which recurs in American painting,

from the naïve landscapes of the early nineteenth century through Albert Pinkham Ryder is found again in the gouaches
159 of Morris Graves. He frequently draws his imagery from an analogy between birds and vision, as in his *Bird in the Spirit*.

Its situation half-way between Europe and the East has left America open to direct influences from either direction. Graves' use of a calligraphic, continuous line to fill in his spaces and give texture to his drawing may be the outcome of his visit to Japan in 1930. It is certainly the base of the 'white-line' style of Mark Tobey, which stems directly from his study of Chinese writing. Other technical devices peculiarly appropriate to watercolour
156 have been used by Sam Francis, in his areas of bold colour
153 allowed to flow down the paper, and by Paul Jenkins who floats one area of wash over another for effects of great chromatic richness.

158 MILTON AVERY, *Roosting Birds*, 1945

159 MORRIS GRAVES, *Bird in the Spirit*, 1940–44

In some ways the earlier autonomy of the watercolour seems to be over. The sheer size of modern painting overshadows the conception of a coloured drawing on a manageable sheet of paper. The nineteenth-century watercolour societies were founded to protect artists from unfair juxtaposition with oils; and that protection is even more needed now. On the other hand the use in painting of almost every imaginable artefact – polystyrene, glass, textile – helps to break down the rigid barriers between one medium and another. A vast painting by Jackson Pollock looks like an enlarged drawing; a canvas with

160 GEORGIA O'KEEFFE, *Blue No. II*, 1916

stains of vibrant thin oil colour gives the visual effect of a big watercolour. The growing demand for colour prints, causing artists to repeat the imagery of their painting in relief colour etching, lithography, screenprint and by other means, is another source from which the watercolour as such meets competition. Yet watercolour – in a much extended sense of the word – is still there as one of the many methods of making coloured marks open to the artist. The wheel has come full circle and its status resembles what it was at the beginning of this survey. It is a tool for sketching and an adjunct for design – for the theatre, for costume, for architecture – and it is the medium for many self-subsistent works which are complete expressions of their authors' minds.

Short Bibliography

The only previous attempt to cover the ground surveyed in this book is to be found in *Das Aquarell* by Lothar Brieger, Berlin, 1923. *Die Handzeichnung* by Joseph Meder, Vienna, 1919, is still the standard work on the techniques and uses of drawing in all media, but he only treats of watercolour incidentally. The British school of watercolour painting has given rise to a prolific literature. Martin Hardie's *Water-colour Painting in Britain*, London, 3 vols., 1966–68, is the fullest and most recent survey of the subject to the end of the nineteenth century, and contains a copious bibliography of general works and monographs on individual artists (vol III, pp. 283–323).

For other national schools of watercolour painting the specialized literature is extremely scanty. For France there are: Philippe Huisman, *French Watercolours of the 18th Century*, London, 1969; François Daulte, *French Watercolours of the 19th Century*, London, 1969; François Daulte, *French Watercolours of the 20th Century*, London, 1968. For nineteenth-century watercolour painting in Holland, Victorine Bakker-Hefting, *L'aquarelle néerlandaise au siècle dernier*, the catalogue of an exhibition held at L'Institut néerlandais, Paris, 1963, is valuable. For the Belgian school the introduction by M. J. Chartrain-Hebbelinck to the catalogue of the exhibition *Aquarelles, Gouaches et Pastels du XIX^e S. à nos jours* held at the Musées Royaux des Beaux-Arts, Brussels, 1964, should be consulted. The catalogue of the exhibition *De Aquarel 1800–1950* held at Het Prinsenhof, Delft, 1952, covers works from a number of European schools. For the United States of America, Albert Ten Eyck Gardner, *History of Water color painting in America*, New York, 1966, gives a well-illustrated survey, and the section in the article 'Water-Colour Painting' dealing with the United States in the current edition of the *Encyclopaedia Britannica* is also useful.

For the rest, the history of watercolour painting as such has to be gleaned from the more general histories of the national schools of art, from the catalogues of special exhibitions, private collections and auction sales, and from the standard monographs on individual artists.

List of Illustrations

Measurements are given in inches and centimetres, height before width.

AVERCAMP, HENDRIK VAN
(1585–1663)
Golf on the Ice
Pen and ink and watercolour, $7 \times 9\frac{3}{8}$
$(17\cdot8 \times 23\cdot8)$
Royal Collection, Windsor
Reproduced by gracious permission of
Her Majesty the Queen 9

AVERY, MILTON (1893–1965)
Roosting Birds, 1945
Watercolour $22\frac{3}{4} \times 30\frac{1}{2}$ $(57\cdot7 \times 77\cdot4)$
Victoria and Albert Museum, London
158

BAKST, LÉON (1866–1924)
The Blue Sultana in 'Scheherezade'
Watercolour 24×15 (61×38)
Private collection 124

BAROCCI, FEDERICO (1526–1612)
Landscape, study for background of the
etching *Stigmatization of St Francis*
Bodycolour $15\frac{1}{2} \times 9\frac{7}{8}$ $(39\cdot3 \times 25)$
British Museum, Department of Prints
and Drawings 3

BARRET, GEORGE (1767/8–1842)
Windsor Castle
Watercolour $20\frac{7}{8} \times 28$ (53×71)
Victoria and Albert Museum, London
69

BLAKE, WILLIAM (1757–1827)
*Dante and Virgil ascending the Mountain
of Purgatory*, 1824–27
Watercolour $20\frac{3}{4} \times 14\frac{5}{8}$ $(52\cdot6 \times 37)$
The Tate Gallery, London 31

The Simoniac Pope, 1824–27
Pen and ink and watercolour $20\frac{3}{4} \times 14\frac{1}{2}$
$(52\cdot6 \times 36\cdot9)$
The Tate Gallery, London 54

BONINGTON, RICHARD PARKES
(1802–28)
Castelbarco Tomb, 1827
Watercolour $7 \times 5\frac{1}{4}$ $(17\cdot8 \times 13\cdot3)$
Castle Museum, Nottingham 64

Bridge of St Maurice, Valais, Switzerland
Watercolour $7\frac{1}{4} \times 9\frac{5}{16}$ $(18\cdot5 \times 23\cdot7)$
Victoria and Albert Museum, London
77

A Venetian Scene
Watercolour $7\frac{1}{8} \times 9\frac{7}{8}$ (18×25)
Wallace Collection, London 78

BOSBOOM, JOHANNES (1817–91)
*Entrance to the Old Women's Home at
Arnhem*, 1849
Watercolour $18\frac{1}{8} \times 14\frac{3}{4}$ $(46 \times 37\cdot6)$
Stedelijk Museum, Amsterdam 109

BOUDIN, EUGÈNE (1824–98)
A Summer's Day: Coast Scene
Watercolour $4\frac{5}{8} \times 7\frac{3}{8}$ $(11\cdot6 \times 18\cdot8)$
Victoria and Albert Museum, London
106

BOYCE, GEORGE PRICE (1826–97)
Catterlen Hall, Cumberland, 1884
Watercolour $12\frac{1}{2} \times 16\frac{1}{4}$ $(21\cdot7 \times 41\cdot3)$
Victoria and Albert Museum, London
86

BRABAZON, HERCULES B. (1821–
1906)
*After Sunset: View from the Artist's
Window in Morpeth Terrace*
Watercolour $10 \times 14\frac{1}{16}$ $(25\cdot4 \times 35\cdot8)$
Victoria and Albert Museum, London
95

BUONTALENTI, BERNARDO
(1536–1608)
*Designs for costumes of two female per-
formers in the Florentine 'Intermezzi' of
1589*
Pen and ink and watercolour $10\frac{3}{8} \times 11\frac{1}{16}$
$(26\cdot5 \times 28\cdot1)$
Victoria and Albert Museum, London
Photo John Webb 18

BURCHFIELD, CHARLES
(1893–1967)
The False Front
Metropolitan Museum of Art, New
York 154

206

207

208

Index

Spilliaert, Léon, 187
Stammbücher (Album Amicorum), 12
Steer, Philip Wilson, 126, 169; *93*
Stillingfleet, Benjamin, 29–30
Sturm und Drang movement, 42, 60
Sutherland, Graham, 174, 175; *135*
Sweden, van Everdingen's drawings of, 22; Desprez's work in, 37, 38
Switzerland, 18th-century watercolour painters of, 39–43; English artists visiting, 64–5, 68, 69, 70; and artists in England from, 42, 43, 60; *see also* Alpine scenery

Taverner, William, 52–4, 68, 70; *34*
Tennyson, Alfred, Lord, 105
Thomson, James, 61
Thornhill, Sir James, 51, 52; *33*
Thorwaldsen, Bertel, 129
Tiffany, Louis, 156
Tissot, James, 136
Tobey, Mark, 194
Toulouse-Lautrec, Henri de, 144
Towne, Francis, 10, 62, 64, 68–70; *49, 53*
Troost, Cornelis, 25; *16*
Turner, Dawson, 97
Turner, Joseph Mallord William, 57, 58, 66, 72, 83–90, 104, 126, 133, 144, 153, 183; *59–61*

Van Dyck, Anthony, 17; *7*
Van Gogh, Vincent, 122, 148; *112*

Varley, John, 72, 84, 98, 99, 102, 107, 108; *70, 71*
Vaughan, Keith, 177
Vernet, Horace, 133
Virgil, 92, 109
Vogels, Guillaume, 149

Wadsworth, Edward, 172
Walden, Herwarth, 184
Walker, Frederick, 123; *90*
Wallace Collection, 133
Walpole, Horace, 61
War Artists Advisory Committee, The, 175
Watercolour painting, definition of, 8; in relation to miniature painting, 9; in relation to Old Master drawings, 9–10; status in 20th century, 163–9, 195–7. *See also*, for national schools, under America, Austria, Belgium, British school, Dutch school, French school, Germany, Italy, Russia, Sweden, Switzerland
Webster, Thomas, 120
Whistler, James Abbott McNeill, 116, 126, 161; *123*
White, John, 16, 47, 48; *5*
Wilson, Richard, 44, 62, 67
Wimperis, Edmund Morison, 120
Windham, William, 29
Wolfe, Edward, 174; *139*
Wouters, Rik, 186
Wyeth, Andrew, 191
Wyngaerde, Anthonis van de, 49

Zuccarelli, Francesco, 31, 39; *20*